20TH-CENTURY AMERICAN SCULPTURE
in the White House Garden

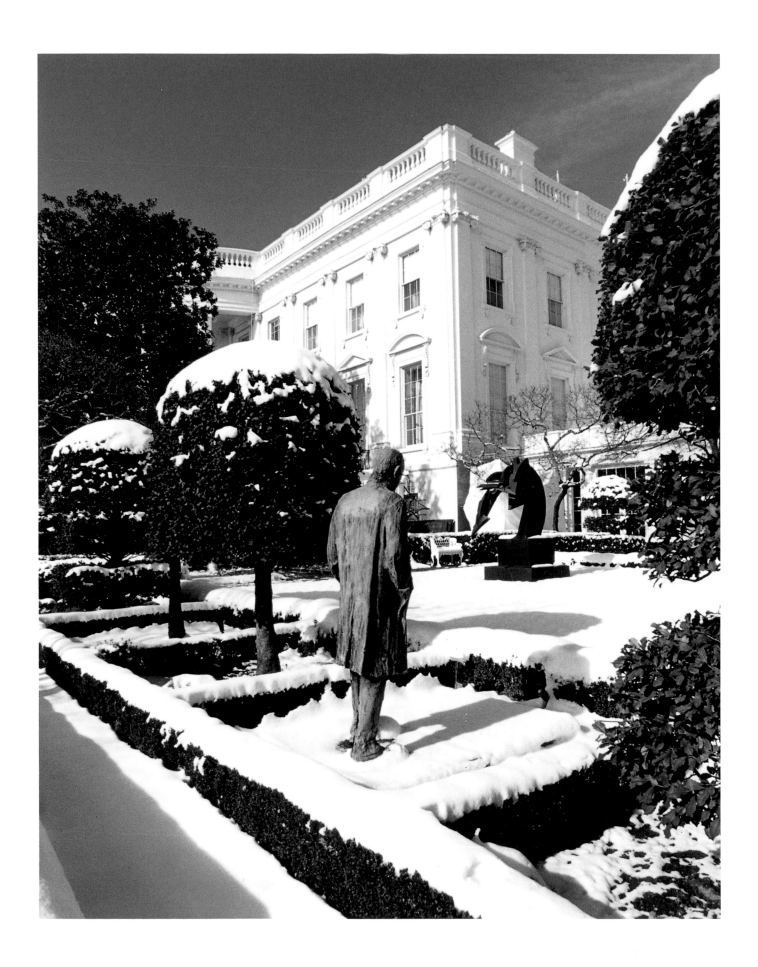

20TH-CENTURY AMERICAN SCULPTURE
in the White House Garden

TEXT AND
PHOTOGRAPHS BY
DAVID FINN

FOREWORD BY
HILLARY RODHAM CLINTON

WITH AN ESSAY BY
BETTY C. MONKMAN

HARRY N. ABRAMS, INC.,
PUBLISHERS

TITLE PAGE: View of sculptures with The White House in the background, January 29, 1995. Photo courtesy The White House

EDITOR: Margaret L. Kaplan
DESIGNER: Maria Learmonth Miller

LIBRARY OF CONGRESS CATALOGING-IN-PUBLICATION DATA

Finn, David, 1921–
 Twentieth-century American sculpture in the White House garden / text and photographs by David Finn ; foreword by Hillary Rodham Clinton ; with an essay by Betty C. Monkman.
 p. cm.
 Includes index.
 ISBN 0-8109-4221-6
 1. Sculpture, American—exhibitions. 2. Sculpture, Modern—20th century—United States—Exhibitions. 3. White House Gardens (Washington, D.C.)—Exhibitions. 4. Sculptors—United States—Biography. I. Monkman, Betty C. II. Title.

NB212.F56 2000
730'.973'074753—dc21
 00-29295

Harry N. Abrams, Inc.
100 Fifth Avenue
New York, N.Y. 10011
www.abramsbooks.com

CONTENTS

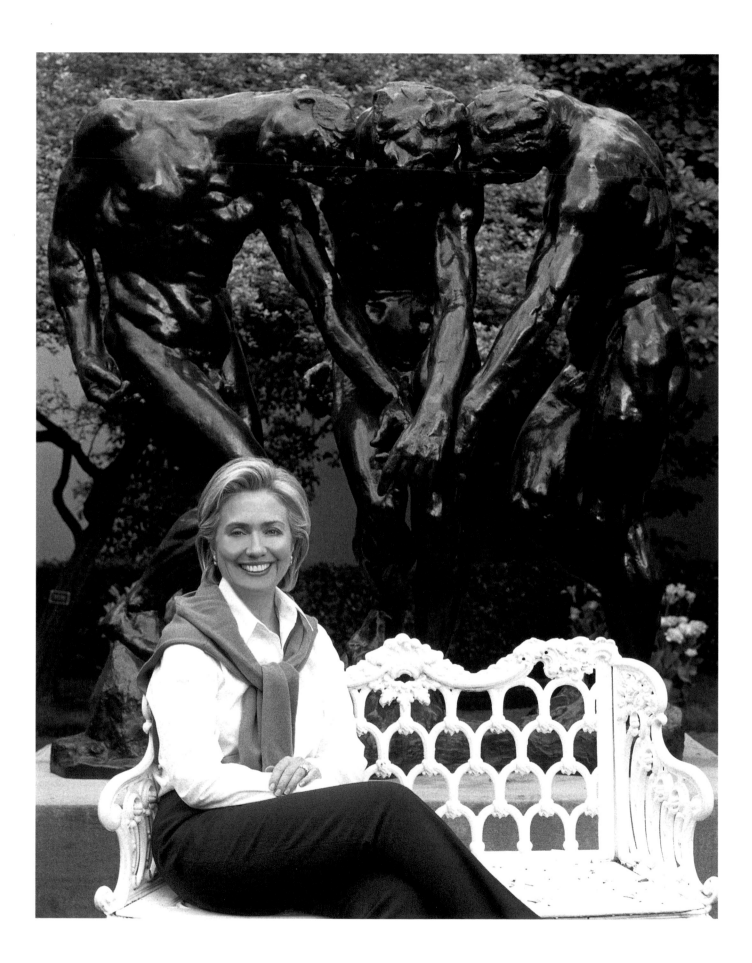

FOREWORD by Hillary Rodham Clinton

PERHAPS YOU'VE HEARD THE STORY OF MY FIRST DATE WITH BILL CLINTON. After standing in line to register for law school classes one afternoon many years ago, we took a walk that led us to the Yale University Art Gallery in New Haven, where a Mark Rothko exhibit was mounted inside and pieces by Henry Moore, including *Draped Seated Woman,* graced the Sculpture Garden. A labor dispute had closed the doors, but Bill managed to talk our way in by offering to pick up trash.

Even as a young girl, I loved sculpture. Contemporary sculpture particularly fueled my imagination. As I grew older, I came to understand that where there is imagination, there is hope. And where there is creative expression, there is the potential for human progress. This is why it disappointed me that among the masterpieces of the White House permanent collection, there was so little sculpture —especially on the grounds. And why I was determined to bring sculpture to this, the "People's House," where it could stir the imaginations of millions more each year.

As you turn the pages of this beautiful book, you will see some of the masterpieces that have graced the White House sculpture garden between 1994, when our first exhibit was mounted, and 2000, when the eighth exhibit was disassembled. What you will discover is not only the richness and diversity of contemporary American sculpture, but also a brilliant reflection of America's imagination, creativity, and progress over the last hundred years—the American century.

Shortly after Bill's 1993 inauguration, I spent a lot of time walking around the eighteen acres of grounds at the White House, where I fell in love with the Jacqueline Kennedy Garden. It looked as if it had been designed for sculpture, and I found myself dreaming of ways to showcase favorite pieces of contemporary American sculpture. With the help of my friend and designer Kaki Hockersmith and J. Carter Brown, former director of the National Gallery of Art, the idea for a sculpture garden featuring works by contemporary American artists took shape.

Hillary Rodham Clinton seated before Auguste Rodin's The Three Shades *during Exhibition 7, which featured works inspired by the French master. Photo by Todd Eberle © William J. Clinton Presidential Foundation*

The idea for these exhibitions was inspired, in part, by First Lady Jacqueline Kennedy, who believed that art should be a part of everyone's life. My much-too-brief friendship with her left an indelible impression, and when it came time to choose a site for the exhibitions, the decision was easy—the garden named for her. I thought about how wonderful sculpture would look amidst the beauty of the surroundings. As an added benefit, siting the sculptures in this garden would make them clearly visible to tourists and other guests moving along the glass-enclosed colonnade between the East Wing and the State Floor.

Our plan, to stage a series of exhibitions overseen by the White House Curators and organized around certain themes, was promptly approved by an enthusiastic Committee for the Preservation of the White House. It was J. Carter Brown who suggested that only outdoor sculpture from public collections be included. And it was Brown who took the idea to the Association of Art Museum Directors. Working together, we agreed initially on four shows, each representing a region of the country. In this way we could showcase not only the art, but some of our country's best public museums as well.

For the first show, we turned to George Neubert, Director of the Sheldon Memorial Art Gallery and Sculpture Garden at the University of Nebraska at Lincoln, and a sculptor himself. As curator of our inaugural effort, he chose to highlight the Midwest's finest museums and to offer an overview of sculpture in the twentieth century. A dozen pieces, spanning 70 years, illustrated the changing face of American art, from the strictly representational to the freer forms of the contemporary artist—from Paul Manship to George Segal, Gaston Lachaise to Judith Shea. As I studied Lachaise's *Standing Woman,* I wondered about the reaction this very large and defiantly naked woman evoked when she was first unveiled in 1932.

This first exhibition, which we opened on a beautiful fall day in 1994, taught all of us a great deal about transporting and displaying sometimes large and unwieldy artistic masterpieces. Very quickly we came to learn that installations were complex undertakings requiring the advice and help of dozens of specialists.

Each show's curator thought long and hard about the selection of individual pieces, considering not just the theme, but the scale and aesthetics of the group as a whole. We wanted to position the works to be seen to their best advantage by visitors to the White House. Large pieces, such as Auguste Rodin's *The Three Shades* and Deborah Butterfield's life-size bronze horses, *Willy, Argus, and Lucky,* fitted well in the open spaces at the ends of the garden. Heavy works, such as Isamu Noguchi's seven-ton basalt *Great Rock of Inner Seeking,* and tall pieces, such as George Rickey's 35-foot-tall *Two Lines Oblique, Atlanta,* required excavation for underground footings beneath their concrete pedestals.

Unlike typical museum exhibitions, the Secret Service had to examine each piece before allowing it to take its place in the garden. We also had to consider the impact of the blustery winds that kick up on the South Lawn whenever the

President's helicopter lands or takes off. We were especially pleased to watch Alexander Calder's *Five Rudders* flutter excitedly, suffering no ill effects as Marine One approached.

On each of the installation days, a large crane was moved into the garden to hoist the works onto their designated sites. We held our breaths as we watched Rodin's *The Thinker*, from the seventh exhibition, lowered onto a six-foot pedestal and as Alexander Calder's *Nenuphar* took its place as the centerpiece of the fifth exhibition. Wandering out to the garden alone in the evenings, I felt renewed and energized by the creative spirit of those who spend their lives bringing beauty to our surroundings and freeing our imaginations to take flight.

We chose an old friend, Townsend Wolfe, Director and Chief Curator of the Arkansas Arts Center in Little Rock, to curate the second show, featuring work from museums in the Southeast. Focusing on art created since 1965, Townsend chose twelve pieces to demonstrate the most modern stage in the evolution of twentieth-century American sculpture. I was especially pleased that eight of the twelve artists were able to join us for the opening reception in May of 1995.

Rounding out the four regional exhibitions, Peter Marzio, Director of the Museum of Fine Arts in Houston, chose eleven pieces representative of the West and the Southwest, and Marcia Tucker, Director of the New Museum of Contemporary Art in New York City, showcased works from the Northeast. Peter treated us to a rare opportunity to view a striking piece of sculpture by Georgia O'Keeffe. Although she is known best for her paintings of the Southwest, her white, lacquered-bronze *Abstraction* is as graceful and serene as any of her paintings.

For the fifth exhibition, Earl A. (Rusty) Powell III, Director of the National Gallery of Art, chose some of the magnificent sculptures found in museums here in Washington. Every time I strolled through the garden, I found myself reaching out to set Harry Bertoia's *Tonal Sculpture* in motion. Bertoia is well known for introducing the dimension of sound into sculpture, in this case a distinctive chime that floated over the garden at the slightest touch of a breeze—or tweak from a passerby.

Martin Sullivan, Director of the Heard Museum in Phoenix, Arizona, collected pieces celebrating the rich diversity of contemporary Native American sculptors—a collection that will always hold a special place in my heart. I'll never forget the traditional blessings offered by Nez Percé Phil Minthorn on the clear, crisp November day when we hosted the opening reception. No one walking past the collection will soon forget Doug Coffin's brightly colored 28-foot *Earth Messenger Totem,* or the 26-foot *Cedar Mill Pole* crafted by R.E. Bartow, both of which were visible from every corner of the South Lawn. Once the pieces were installed, these two totems were, quite by accident, in exact alignment with our most famous local totem—the Washington Monument.

The collection unveiled in November of 1998 marked a distinct departure. Organized by Arnold Lehman, Director of the Brooklyn Museum of Art in New

York and subtitled *Inspired by Rodin,* this group for the first time included work by a non-American, in this case, three pieces by the French master himself. Often called "the father of modern sculpture," Rodin worked in Paris in the late nineteenth and early twentieth centuries. But his influence on American artists has been dramatic and can be seen in several of the pieces in this group—among them, De Kooning's *Clamdigger,* Segal's *Girl Standing in Nature,* and Noguchi's *Woman.*

The eighth exhibition, titled *The View from Denver,* opened in October of 1999. Organized by Lewis Sharp, Director of the Denver Art Museum, this collection included pieces that exemplified a microcosm of the trends that have shaped twentieth-century American art. In addition, the group included some of my favorite kinetic works—George Rickey's *Two Open Trapezoids Excentric V,* the wildly colorful *Windsong III* by Robert Mangold, and another Bertoia. Kinetic sculptures show off when they're exhibited outdoors—sometimes rocking and spinning garrulously, other times barely fluttering on the light breeze. When George Rickey's *Two Lines Oblique, Atlanta* was on display, Bill and I would often just sit on the Truman Balcony, looking down at the 35-foot stainless-steel sculpture as it quivered gracefully in the wind.

Although dozens of museums have been involved in choosing and lending appropriate pieces for these exhibits, none of them could have undertaken the expense of mounting such a series alone. For that, we turned to one of this country's most important arts patrons—and a dear friend—Iris Cantor. Along with her late husband, B. Gerald Cantor, and the Cantor Foundation, Iris agreed not only to underwrite the expense of the exhibits, but also to lend the anchors of the *Inspired by Rodin* group—castings of *The Three Shades* and *The Thinker.* At the beginning of the Administration, the Cantors also lent a small casting of *The Thinker* to the President, who keeps it in the Oval Office.

As many as 12 million visitors have walked past the Sculpture Garden since that October day in 1994 when the first exhibit opened. They have been treated to such American masterpieces as George Segal's *Walking Man* and Ellsworth Kelly's *Curve VIII.* They have enjoyed works by Georgia O'Keeffe, Willem de Kooning, Roy Lichtenstein, Isamu Noguchi, and Allan Houser. The outpouring of appreciation has been overwhelming, with visitors frequently telling our guides how much it means to them to view this wonderful art while waiting to see the White House.

As I look back to January of 1993, when I first dreamed of bringing sculpture to the White House, I realize that one of the great pleasures of living here has been the opportunity to make this dream come true. It could never have happened without the inspiration, imagination, support, and dedication of Kaki Hockersmith; J. Carter Brown; Rex Scouten and Betty Monkman, along with their staff in the White House Curator's Office; Iris Cantor and the Cantor Foundation; the directors and staff of the eight museums that organized the exhibits; and the other lending institutions that so generously agreed to share cherished parts of

their collections with us. But most of all, none of this would have been possible without the sculptors themselves. It is they, with their vision, their imagination, and their creative spirit, who have given us enjoyment and inspiration.

The President and I understand that we are privileged tenants of this grand house and stewards of its history. We share a deep commitment to opening these doors as widely as possible, sharing the art and culture that is so uniquely American. The White House and its permanent collection of art and furnishings belong to the people of the United States. While we were able to enjoy these eight exhibitions for only a short time, I am grateful that, thanks to this book, they will be immortalized as part of the history of this house, which means so much to our country.

Slipping out to the sculpture garden to spend time alone among the work of some of this country's greatest contemporary artists has turned out to be one of the special pleasures of living in the White House. Although now the pieces have returned to their permanent homes, what you will find in the pages that follow is not only a handsome catalogue of the eight exhibitions, but also a fitting tribute to America's rich artistic tradition.

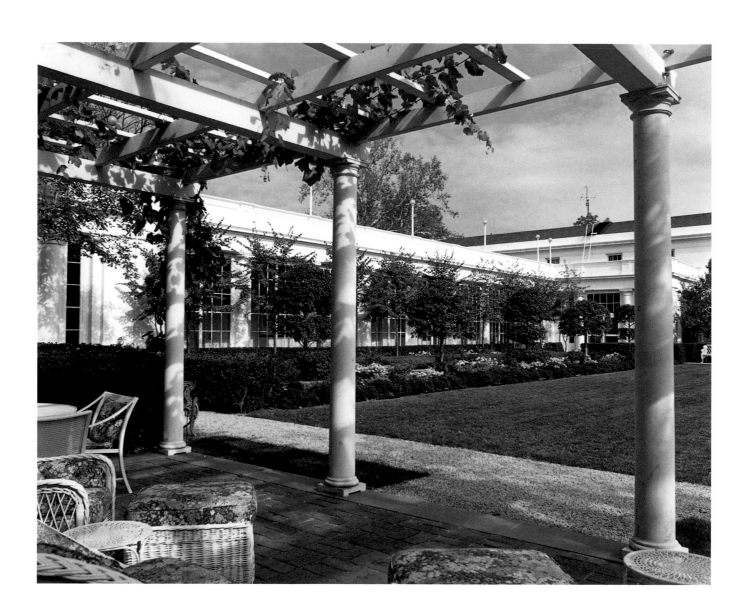

THE SETTING: THE JACQUELINE KENNEDY GARDEN

by Betty C. Monkman, CURATOR, THE WHITE HOUSE

THE JACQUELINE KENNEDY GARDEN, AN INTIMATE, QUIET SETTING WITH VISTAS
to the south lawn, has been the venue for eight exhibitions of twentieth-century
American sculpture. The first exhibition took place in 1994 and the last extended
into the year 2000. The works were displayed in a garden designed to be shared by
visitors to the White House and the families who live there. This garden, on the
east side of the White House, adjoins the glass-enclosed East Colonnade through
which 1.2 million visitors begin their tour of the President's House each year. When
Lady Bird Johnson dedicated the garden to Jacqueline Kennedy in April 1965, she
remarked that President and Mrs. Kennedy "loved beauty and they loved it in the
sturdy American tradition of seeking the beautiful that is also useful. . . . and it is in
this spirit that they planned the garden in which we stand. . . . The loveliness is
here in profusion—whether the trimness of the arbor green or the burst of holly
red or the serenely inviting paths."

In 1961, President John F. Kennedy requested Rachel Lambert Mellon, a
friend and avid gardener and horticulturist, to renew and redesign the Rose Garden
located on the west side of the White House near the Oval Office. Mrs. Mellon
wrote that the garden, completed in 1962, fulfilled President Kennedy's vision of a
garden that would endure and whose atmosphere would suggest the ever-changing
patterns of history itself. The success of the Rose Garden led the President to ask
that Mrs. Mellon continue her work by improving the East Garden, which had
remained unchanged, except for some modifications in 1952, since the Woodrow
Wilson administration.

Variously named the East Garden and the First Lady's Garden, it has
always been a private garden for the first family and their friends. A small orangery,
located at the east end of the colonnade, was created in the 1830s by President
Andrew Jackson; it supplied year-round citrus fruits for the President and housed a

*View of the Jacqueline
Kennedy Garden from the
pergola, November 2, 1965.
Photo courtesy Lyndon B.
Johnson Library, Austin, Texas*

13

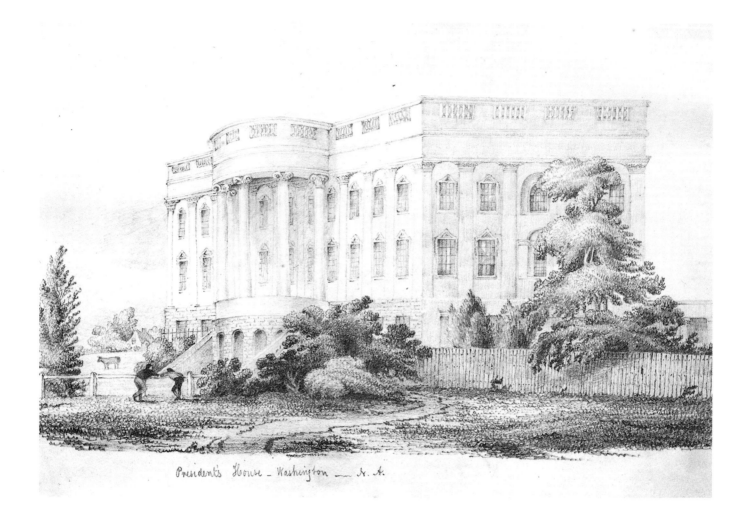

President's House - Washington - *N. A.*

South view of The White House, 1830s (artist unknown). Photo courtesy The White House

variety of tubbed plants. Adjacent to it was a garden that served as a private retreat, sealed off from the public on the south by a tall picket fence. (The grounds of the President's House had been open to the public throughout the nineteenth century.) Dogwood and redbud trees, fragrant lilacs, and camellias provided a peaceful place removed from politics and the demands of White House social life. Cast-iron garden settees in the Gothic revival style, still in use, were purchased for the gardens and grounds in 1852 under President Millard Fillmore, who enjoyed the gardens. The orangery and garden were demolished in 1857, when the Treasury Department was extended to the south and west. Little is known about the space in the last half of the nineteenth century because it was shielded from the public, but there were probably parterres and walks for family strolls. Large shade trees appear in images from the time.

It took a First Lady with a strong interest in gardening to create a formal garden for the new century. Edith Roosevelt came to the White House in 1901 when her husband, Theodore, assumed office upon the death of William McKinley. The Roosevelts made extensive changes to the interior of the White House and removed

the offices of the President and his staff from the floor shared with the family to a new separate office wing, now called the West Wing. It was built in the area formerly occupied by the White House greenhouses and conservatories, which were torn down in 1902. A new East Wing with a porte-cochère was constructed as the formal entrance for guests invited to social functions. Mrs. Roosevelt worked closely with Charles McKim, of the noted New York architectural firm McKim, Mead & White who was engaged to plan and oversee the changes. He was asked to coordinate the Roosevelts' ideas for the grounds and gardens; Edith Roosevelt also conferred with a friend, the author Edith Wharton. The result was Mrs. Roosevelt's request to McKim that the gardens on the east and west be "extremely simple" with the character of the gardens at Mount Vernon—divided into parterres (flower beds) surrounded by close-cut garden hedges. McKim consulted with the landscape architect Frederick Law Olmsted, Jr., in Boston. (His firm would, in the 1930s, be involved in major changes to the grounds for President Franklin D. Roosevelt.)

The East Garden, as designed in 1903, was a formal garden reflecting the turn-of-the-century interest in Colonial style. The Colonial Revival looked back to the period of the nation's origin for inspiration in architecture, house interiors, and gardens. At spring garden parties in the East Garden, Mrs. Roosevelt's guests walked along the graveled paths to view the flower beds of roses and lilies outlined with boxwood and privet.

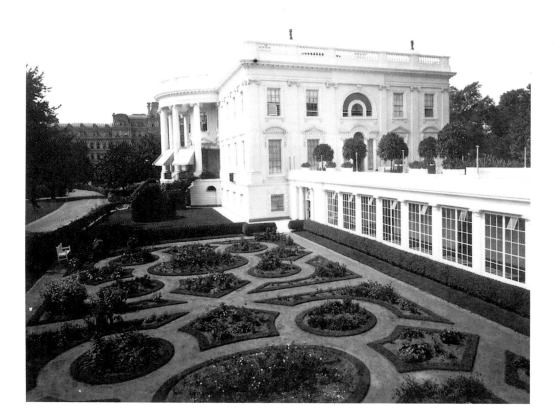

The East Garden during the Theodore Roosevelt administration. Photo courtesy The White House

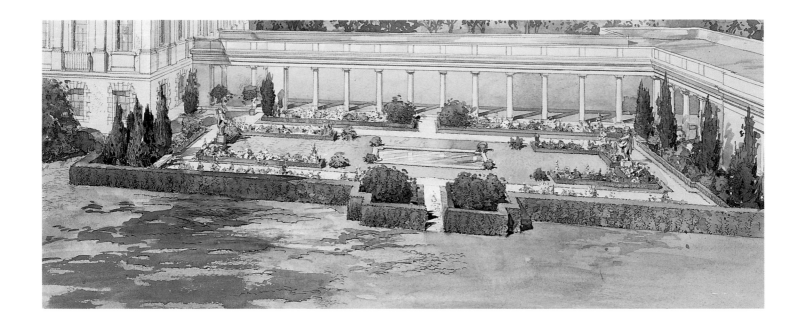

Top: Beatrix Farrand's watercolor plan for the East Garden during the Woodrow Wilson administration, 1913. Photo courtesy University of California, Berkeley

Above: Garden settee, c.1914. Photo by Erik Kvalsvik, courtesy The White House

Opposite: The East Garden during the Woodrow Wilson administration. Photo courtesy The White House

Ten years later, another First Lady with a strong interest in gardens, Ellen Wilson, created the Rose Garden on the west and influenced changes in the East Garden. A painter of landscapes and a friend of many prominent American artists, Mrs. Wilson created a studio in the White House attic where she could paint. In 1913, the first year of the Wilson administration, she invited Beatrix Jones Farrand (1872–1959), a highly respected landscape gardener then at the beginning of her career, to submit plans for the East Garden. Farrand later designed many private gardens, including those at Dumbarton Oaks in Washington, D.C., and several college and university campuses, such as Princeton and Yale. Her plan for the East Garden called for an expansive green lawn with a rectangular lily pond in the center, surrounded by ivy plantings, evergreens, and four L-shaped flower beds in the corners and beds along the four sides. Large cedar trees on the east and west provided privacy. It was probably Farrand who arranged for the installation of the rustic limestone garden settees, chairs, and seats carved with entwined grapevines, corn stalks, fruit branches, weasels, dachshunds, and grouselike birds. These unusual examples of garden furniture, possibly of German origin, remain in the garden today.

The garden was completed in 1914, the year Ellen Wilson died. Her influence on the garden endured for over fifty years. Changes made in 1952, at the end of the massive Truman renovation of the White House, simplified the garden with the removal of overgrown plants and evergreen trees. The pool and the parterres in the center section were replaced with an open lawn flanked by four rectangular flower beds containing a variety of perennials. A large stone urn on a pedestal, a gift from the Italian government in 1952, was placed in the center of the lawn and surrounded by floral plantings.

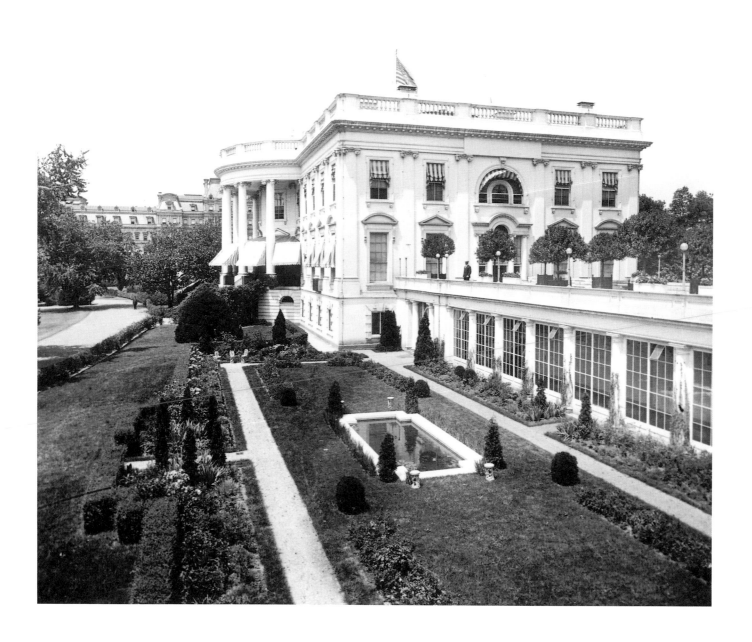

Shortly after moving into the White House in 1963, Lady Bird Johnson asked that the preliminary plans for the garden, begun by Mrs. Mellon with the assistance of landscape architect Perry Wheeler and approved by President and Mrs. Kennedy and the National Park Service, be continued. Working with the White House gardening staff, the garden, 126 feet by 87 feet, was completed by the fall of 1964. The plan retained a grass panel in the center, but the flower beds were removed. The north and south sides were framed by holly osmanthus hedges and square planting beds separated by low boxwood. In the center of ten beds are clipped American holly trees similar to the topiary used at the Governor's Palace at Williamsburg. Also in the beds are herbs for White House chefs—chives, marjoram, rosemary, thyme, tarragon, basil, and santolina. At the northwest and southeast corners were placed two large Magnolia Soulangeana Alexandrina like those in the Rose Garden, all planted at the request of President Kennedy. A row of lindens was installed to provide shade along the glassed-in East Colonnade. The east end was planted with hollies, magnolias, lilacs, and flowering crabapples, and a shallow pool was placed there along with a bronze sculpture, *The Gardener,* by Sylvia Shaw Judson (1897–1978), a gift of Mrs. Mellon. It was her suggestion that a painted wood pergola be constructed at the west end; Concord grapevines were planted to cover it. Here, First Ladies and their guests could have a shady, quiet place in which to visit or read.

Although the plantings have matured since 1965, there have been few changes in the garden. Seasonal annuals are set in the garden three times a year. In the spring, tulips, candytuft, jonquils, violas, hyacinths, narcissus, allium, Virginia bluebells, and other varieties are in bloom. With summer come geraniums, impatiens, ageratum, and lilies. Chrysanthemums, asters, salvia, and sage bring autumn colors.

Mrs. Kennedy did not want the garden named in her honor because she felt that the President deserved credit for the gardens, but she consented to have her

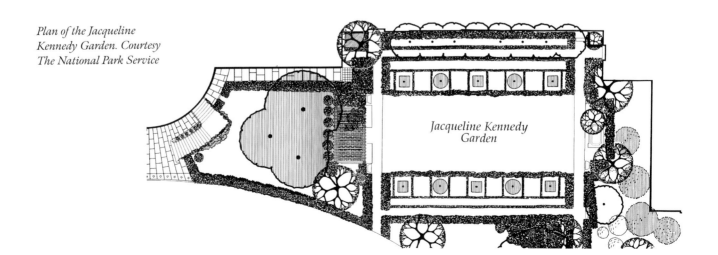

Plan of the Jacqueline Kennedy Garden. Courtesy The National Park Service

Jacqueline Kennedy Garden

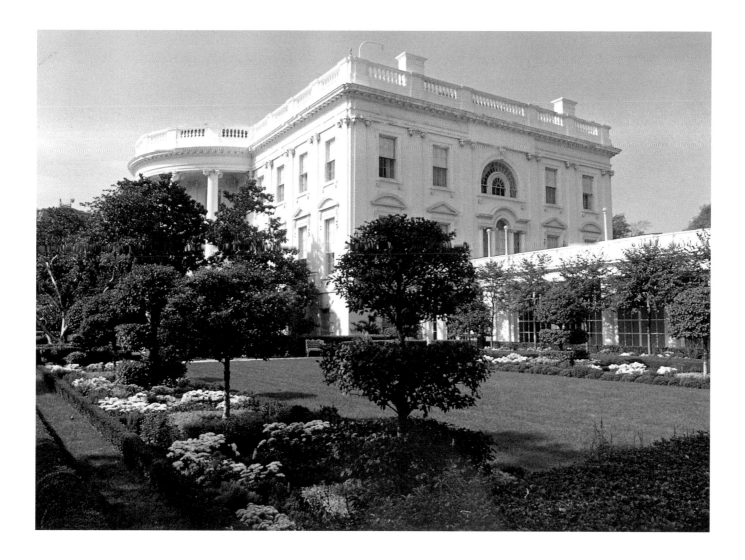

The Jacqueline Kennedy Garden, October 13, 1967. Photo by Robert L. Knudsen, courtesy Lyndon B. Johnson Library, Austin, Texas

name "scratched" on the back of a garden bench; that idea was altered to become a permanent silver plaque placed on one of the columns of the arbor. It reads: "This garden is dedicated to Jacqueline Kennedy with great affection by those who worked with her in the White House." In her comments at the dedication ceremony, Mrs. Johnson spoke for the nation when she stated: "I dedicate it to the enduring heritage she has given all of us." Mrs. Kennedy's contributions to the White House art collection and the history and character of the house endure in the permanent collection of paintings and sculpture, which has inspired other First Ladies to add to that collection and support American art, as Hillary Rodham Clinton has done with her leadership in the eight exhibitions of American sculpture. As the White House does not collect works by living artists, except for portraits of Presidents and First Ladies, the sculpture exhibitions have provided a showcase for the work of America's foremost twentieth-century sculptors.

There is an earlier precedent for installing sculpture in the garden. In 1965, Lady Bird Johnson sponsored a one-day White House Festival of the Arts, and

pieces by noted American sculptors such as Jacques Lipchitz, Paul Manship, Leonard Baskin, Chaim Gross, and Isamu Noguchi were lent by American museums. Works by Harry Bertoia, Alexander Calder, Louise Nevelson, David Smith, and William Zorach—all represented in the 1994–2000 exhibitions—were displayed on the south lawn with those of other sculptors.

The Jacqueline Kennedy Garden, with its sculpture, has provided a place of reflection and repose and a special opportunity for White House occupants and visitors to view the work of America's foremost artists.

PREFACE by Iris Cantor

CHAIRMAN AND PRESIDENT, IRIS AND B. GERALD CANTOR FOUNDATION

THE IRIS AND B. GERALD CANTOR FOUNDATION HAS BEEN DELIGHTED TO support the presentation of the important series of sculpture exhibitions at the White House during the Clinton Administration. Organized by the directors of major American museums in different regions of the United States, this unique undertaking has enabled millions of visitors to the White House to see the work of the finest American sculptors of the twentieth century. I wish to express my gratitude to President and Mrs. Clinton for the honor of being part of such a worthy cultural program.

Conceived by First Lady Hillary Clinton as a way of demonstrating the role played by the arts in our daily lives, the sculptures had the benefit of a magnificent setting in the Jacqueline Kennedy Garden and in the entranceway through which all visitors pass on their public tours. Artists and museum professionals throughout the country have applauded this unique way of showcasing America's commitment to the visual arts.

One of the goals of our Foundation is to promote the recognition and appreciation of excellence in the arts; to enhance cultural life internationally through the support of art exhibitions, scholarships, and the endowment of galleries at major museums. We have a special interest in making the work of Auguste Rodin available to a wide public audience, and my late husband, Wall Street financier B. Gerald Cantor (1916–1996), was widely recognized as the preeminent American collector of the work of this great French master. President Clinton began his first term in 1993, and he was delighted when my husband lent a small version of Rodin's *Thinker* for placement in the Oval Office. We were most gratified when it was decided that the seventh exhibition in the series would show the influence of Rodin on American sculptors during this past century.

I would like to extend my appreciation for the publication of this book and to all those involved in making this program such an outstanding success.

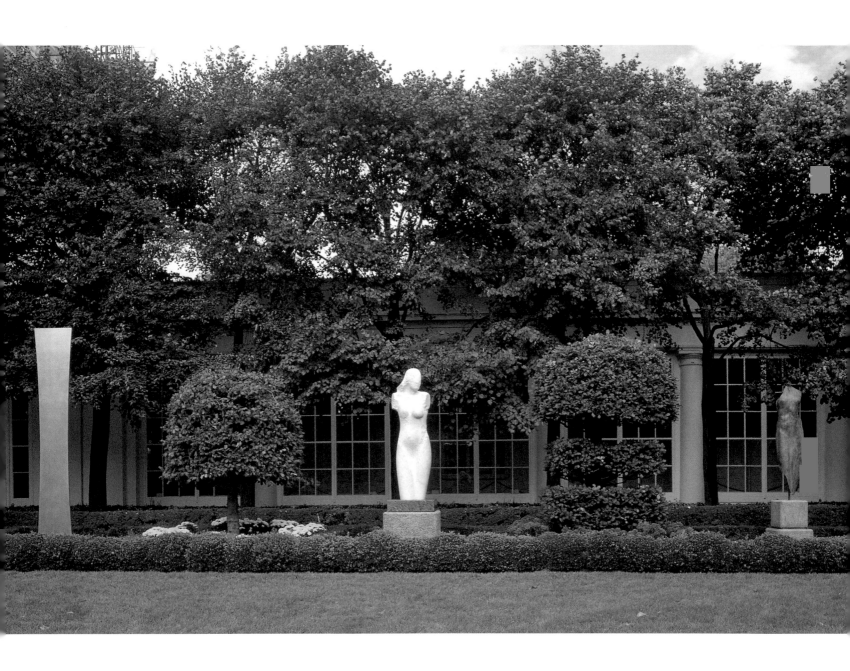

THE SCULPTURES: THROUGH MY CAMERA LENS
by David Finn

PHOTOGRAPHING SCULPTURES IN OUTDOOR SETTINGS HAS ALWAYS BEEN a challenge for two reasons: First, there is the question of how light will fall on the sculptures at the time I happen to be photographing. Will they be in sunlight, in gray light under clouds, or in the darkness of a rainy day? The second has to do with the environment in which the sculpture is sited—will it be possible to find views of foliage in the background? If there are buildings in the area, will the lines interfere with the forms of the sculpture? Will it be possible to find some angles of the sculpture against the sky?

Light is a particularly important factor, since highlights and shadows affect the way most sculptures are revealed through the camera lens. A sunny day is almost always a blessing because bright, natural light can bring out the quality and color of the surfaces. But then there is the problem of shadows, which may reveal the forms or distort them. On a cloudy day, surface subtleties may be lost, but parts of the sculpture that would otherwise be hidden in deep shadow can be seen more clearly. Rainy weather would seem to be the worst, since the photographer and his equipment can hardly avoid getting wet, but I have photographed in the rain with fortunate results. It is a pleasant surprise to find that streaks of water flowing down the surface of a sculpture add a welcome accent to its forms. Snow, on the other hand, can sometimes do a disservice to the sculpture, since the haphazard way in which the white flakes fall on the work owes more to gravity and chance than to enhancing the design of the work itself.

At least as important as the weather and the way light falls is the siting of the sculpture. To make a photograph that does justice either to the whole work or to a detail, one must compose all the elements in one's viewfinder, including the background. If there is a confused jumble of forms around or behind the sculpture, there is almost no way to make a good photograph. But if it is possible to find a

View of sculptures from Exhibition 1 with the East Colonnade in the background. Photo © David Finn

good composition between the interrelation of the forms of the sculpture and the forms in the background, the result can itself be a work of art.

All this was very much on my mind when I volunteered to photograph the sculpture exhibitions in the Jacqueline Kennedy Garden at the White House. The project seemed a wonderful way to highlight President and Mrs. Clinton's interest in the visual arts, and an ideal opportunity for thousands of visitors to the White House to see the best of American sculpture.

Before I arrived, I was concerned that the individual works might not have enough space for proper viewing. Having photographed contemporary sculpture in such great open fields as the Storm King Center in Mountainville, New York; the Yorkshire Sculpture Park in England; and the Open-Air Museum in Hakone, Japan, I wondered if the Jacqueline Kennedy Garden would be too cramped a setting.

My worry proved groundless. When I arrived with my camera equipment, I saw that each sculpture had been placed with great care. The plantings in place for the exhibition were magnificent. The garden looked so right with the sculptures in place that it seemed almost as if they had been there for years.

The first exhibition, which opened in October of 1994, was organized by George W. Neubert, Director of the Sheldon Memorial Art Gallery and Sculpture Garden at the University of Nebraska-Lincoln. The works were chosen from museums in the Midwest—St. Louis, Akron, Chicago, Milwaukee, St. Paul, Columbus, and Minneapolis.

On that first day, the weather was changeable, and whenever a cloud passed overhead I had to alter my aperture settings. I take Polaroid shots to check the exposure as well as the composition before clicking my shutter for the actual photograph, bracketing each shot with three different exposures. As the sun moved across the sky in the course of the day, the sculptures on the south side of the garden, all of which faced the center, were lit from the back rather than the front. It all made the project quite challenging!

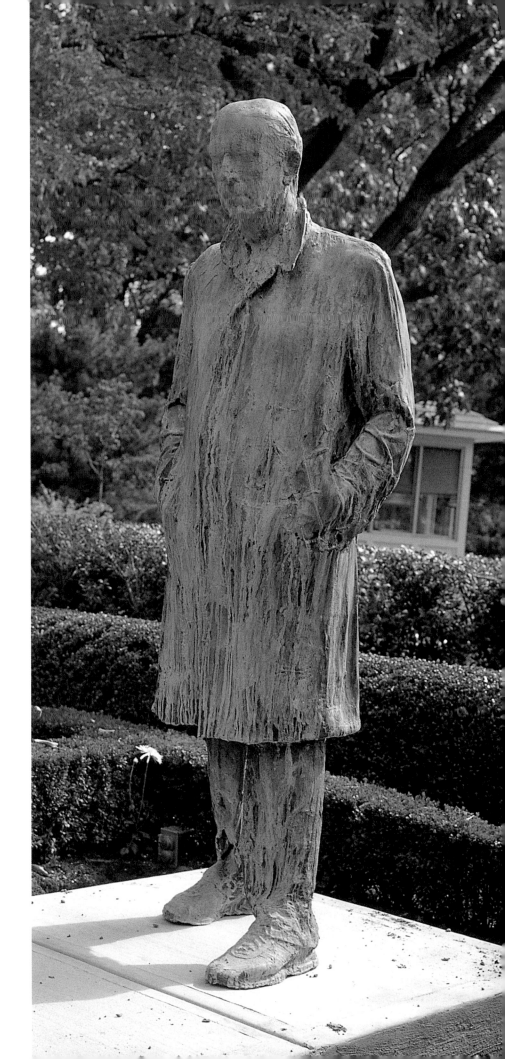

1

George Segal's *Walking Man* was very simply dressed, wearing a topcoat turned up at the collar and trousers that drooped loosely over his everyday work shoes. His hands were in his pockets to keep them warm, and the expression on his face was that of someone lost in thought. The sculpture seemed a fine choice for a President and First Lady who had demonstrated their concern for the welfare of the working men and women of America. The setting was remarkably appropriate as well. With cleanly clipped hedges in the background and the bright yellow and orange blossoms of chrysanthemums nearby, this working man seemed to be taking a walk in the park on a Sunday afternoon.

George Segal (born 1924). Walking Man. *1988. Bronze, 72 x 36 x 30". Walker Art Center, Minneapolis: Gift of the AT&T Foundation and of the Julius E. Davis family in memory of Julius E. Davis, 1988.© George Segal / Licensed by VAGA, New York, NY*

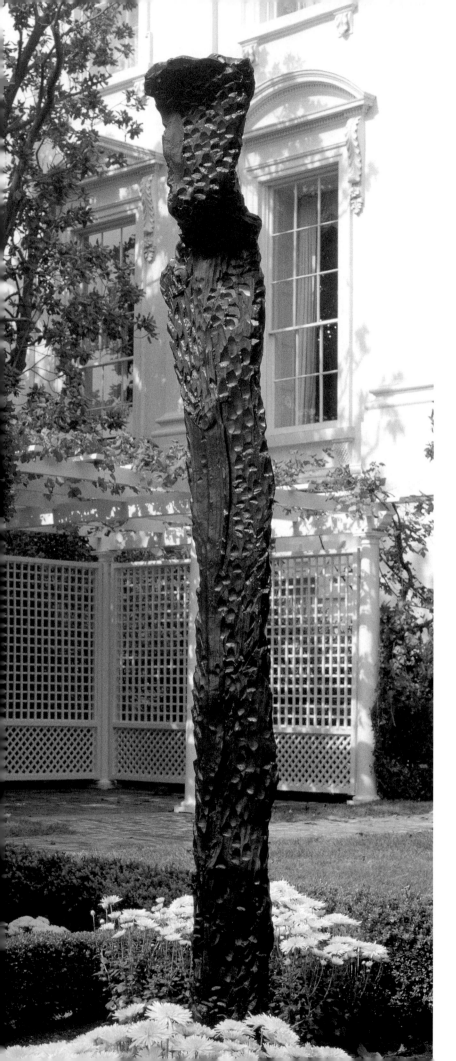

Nearby was Bryan Hunt's *Shift Falls*, representing a waterfall coming out of the sky and flowing between two trees. It was his way of showing an instant in time, and the water appeared to be frozen in space, turning and twisting as it dropped to the ground. Hunt is a sculptor who admires the work of classical artists and expresses a vision similar to theirs in an idiom related to the work of the Abstract Expressionists.

Bryan Hunt (born 1947). Shift Falls. 1978. Bronze, 114 x 20½ x 23¼". Collection of The Akron Art Museum: Museum Purchase with funds from an anonymous donor. © 2000 Bryan Hunt / Artists Rights Society (ARS), New York

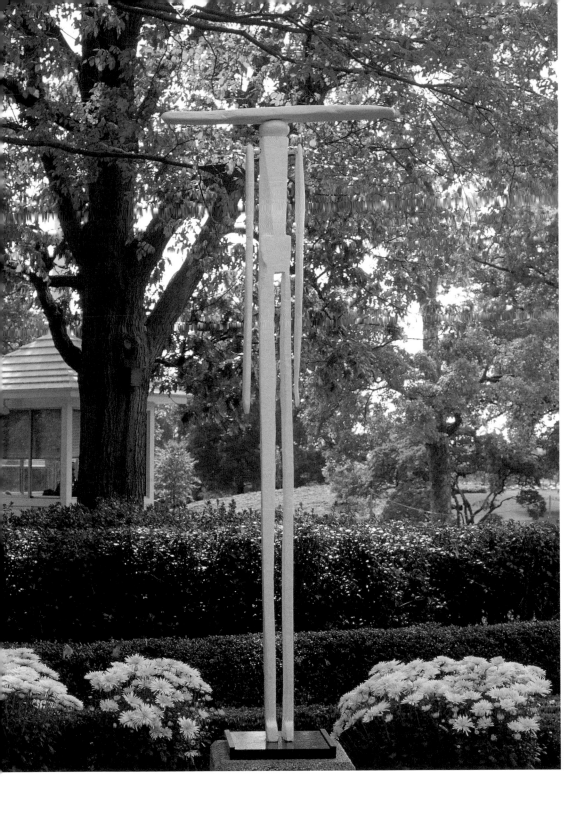

Louise Bourgeois (born 1911).
Observer. 1947–49.
Bronze with white paint,
76 ¼ x 29 x 10 ⅛". Sheldon
Memorial Art Gallery
and Sculpture Garden,
University of Nebraska–
Lincoln. Olga N. Sheldon
Acquisition Trust, 1988.
U–4087. © Louise Bourgeois /
Licensed by VAGA, New
York, NY

On the same side of the garden was Louise Bourgeois's *Observer*. One of the

most original sculptors of our time, Bourgeois has invented new ways to portray

significant aspects of the human experience. The stark white forms of *Observer*,

with its horizontal bar across the top suggesting an ability to see into the distance,

imply the universal human desire to peer into things.

Also nearby was Louise Nevelson's *Tropical Tree III*, looking very much at home as it stood in front of a cluster of White House trees. Nevelson's tropical representation was full of inventiveness as it contrasted with nature's more familiar shapes. It was a study in geometric forms—triangles, rectangles, steel rods—all composed in a remarkable unity that exemplified the strength of her aesthetic vision.

Louise Nevelson (1899–1988). Tropical Tree III. 1972. Aluminum, 64 x 34 x 25". Columbus Museum of Art, Ohio: Given in memory of Frances N. Lazarus by the Charles Y. Lazarus family. © 2000 Estate of Louise Nevelson / Artists Rights Society (ARS), New York

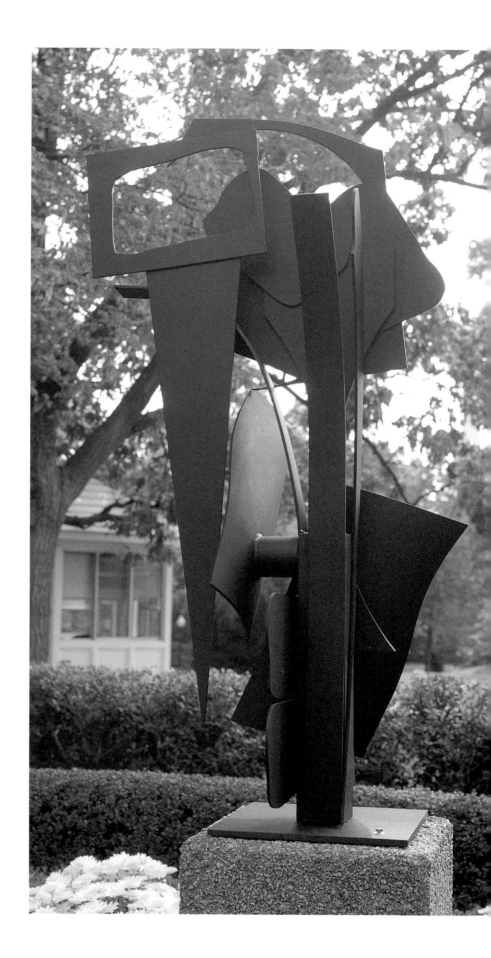

At the east end of the garden was a major Calder mobile/stabile called *Five Rudders*.

The red base was a multisided pyramid on top of which were mounted a group

of beautifully shaped black fins that moved about in the wind. As in all of Calder's

work, there was a sense of perfect balance in the way the forms interacted with each

other. It stood alone at the end of the garden, and its vibrant color and graceful moving

shapes looked especially striking against the exterior walls of the White House.

*Alexander Calder
(1898–1976).* Five Rudders.
*1964. Painted sheet metal
and rods, 126 x 98¼ x 112".
Washington University
Gallery of Art, St. Louis:
Gift of Mrs. Mark C.
Steinberg, 1964. © 2000
Estate of Alexander Calder
/ Artists Rights Society
(ARS), New York*

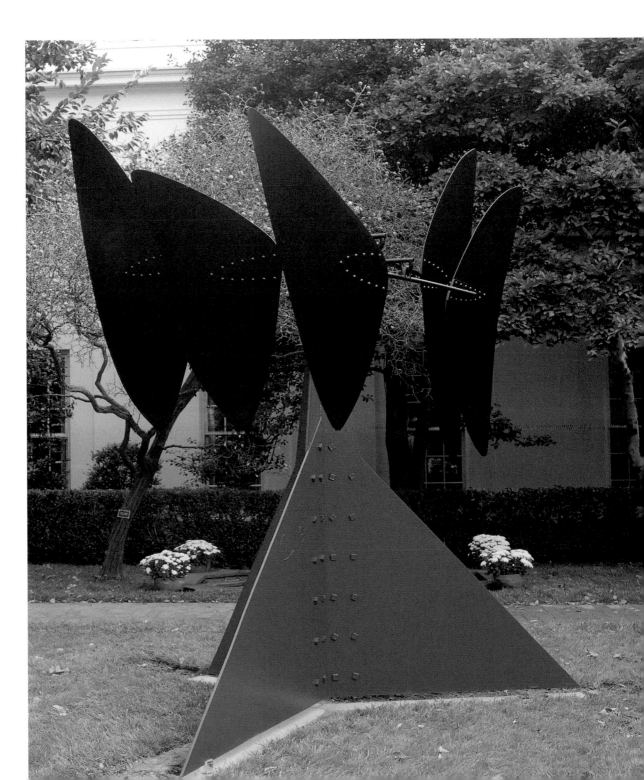

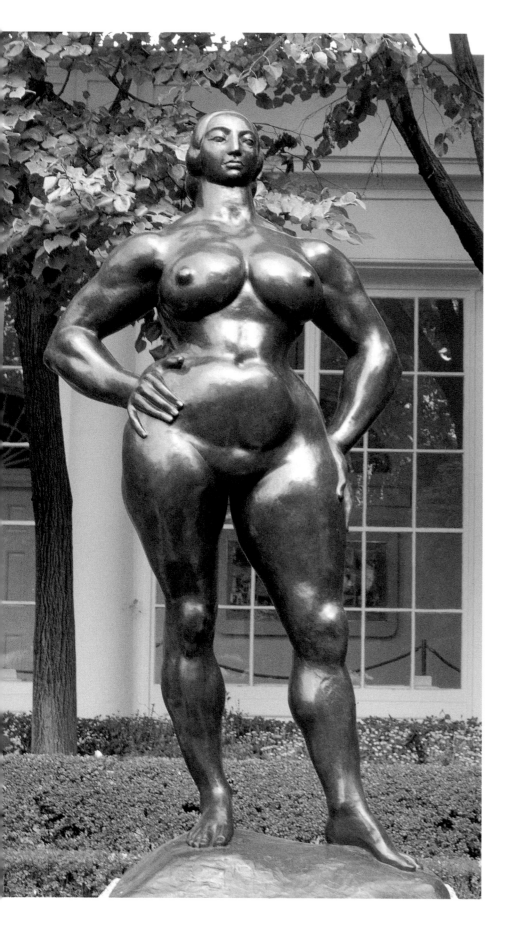

On the southeast side of the garden was Gaston Lachaise's *Standing Woman*, hands on hips, self-assured and proud of her fulsome figure. Lachaise's "Woman" sculptures, which comprise the bulk of his work, were his way of expressing his sensuous passion for his wife, Isabel. The monumental sculpture shows a woman with a forceful physical presence—her large breasts, wide hips, and swelling thighs looked much larger than life in front of the windows of a White House corridor.

Gaston Lachaise (1882–1935). Standing Woman. 1932 (cast 1980). Bronze, 88½ x 41½ x 24¾". Milwaukee Art Museum: Virginia Booth Vogel Acquisition Fund

Against dark foliage, the carved white
stone of Manuel Neri's *Aurelia No. 1*
shone in the sunlight. The breaks where
the arms were cut off and where the
flowing hair ended gave the sculpture
something of a supernatural look.
Neri's chisel marks added a special
character to the stone.

Manuel Neri (born 1930). Aurelia No. 1. *1992.
Marble with oil-based enamel, 72 x 23½ x 23½".
High Museum of Art, Atlanta, Georgia. Gift of
Aurelia and George Schlapp*

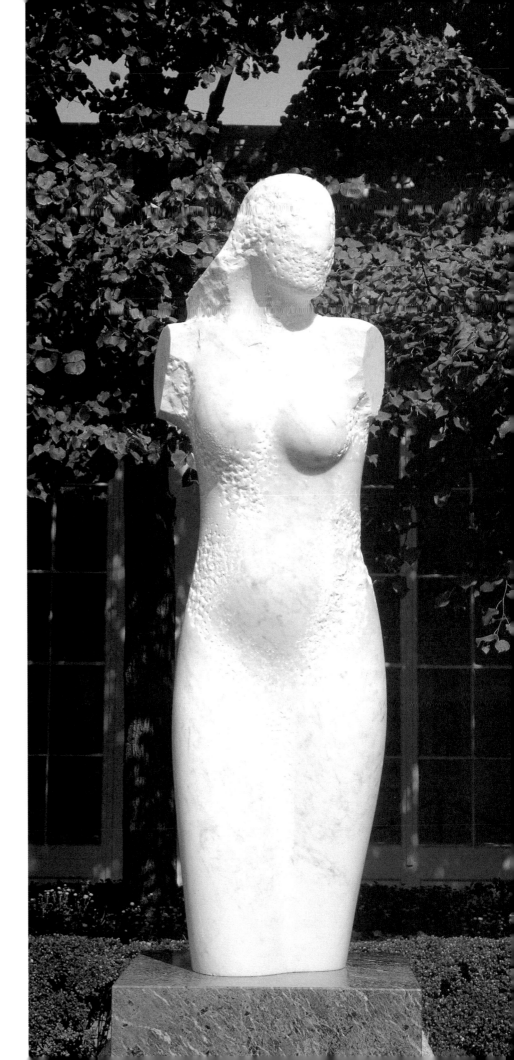

Judith Shea's *Shield* stood nearby. Its delicate forms hinted at the figure of a woman faintly seen in a clinging dress. It had both a classical sensitivity and a modern minimalist feeling, like a fragment of an ancient work that is strangely in tune with modern times.

Judith Shea (born 1948). Shield. *1989. Bronze with limestone base, 56 x 15¼ x 11½". Sheldon Memorial Art Gallery and Sculpture Garden, University of Nebraska–Lincoln: Olga N. Sheldon Acquisition Trust and the National Endowment for the Arts, 1990. U–4272*

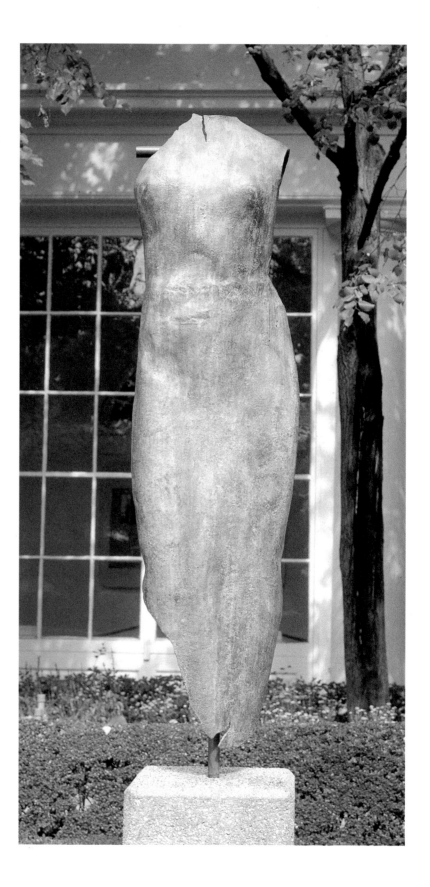

Ellsworth Kelly's *Curve VIII*, one of his brilliantly shaped forms, is monumental in its simplicity. When I photographed it, I was struck by the shadings on the aluminum surface that subtly changed from light to dark, adding depth to the image. Its slender, graceful curves gave the form an undeniable dignity.

Ellsworth Kelly (born 1923). Curve VIII. 1974. Aluminum, 120 x 20 x ¾". The Art Institute of Chicago: Gift of the Society for Contemporary Art

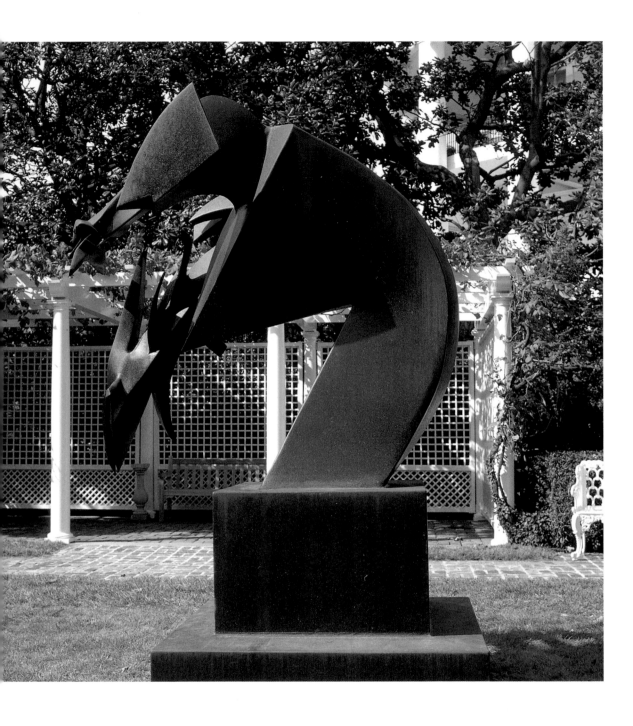

Richard Hunt (born 1935).
Farmer's Dream. *1980.*
Cor-ten steel, 109 x 54 x 76½".
The Museum of Contem-
porary Art, Chicago:
Gift of Mallinckrodt
Group, Inc., in recognition
of Richard A. Lenon

At the west end of the garden, opposite the Calder, stood *Farmer's Dream* by

Richard Hunt. A large, fabricated work, it spilled over to one side in a cluster

of forms. It is one of those works that is a delight to photograph: I could

move around it again and again, finding an almost endless number of abstract

compositions. The sun shone on some of the parts, producing strong high-

lights, while other parts were in shadow, creating striking contrasts.

Just inside the glass windows of the White House at the entrance to the garden, two additional sculptures were also part of the exhibition. Since the garden could be seen through the window, they related well to the ones outdoors. They were by Paul Manship—one called *Diana* and the other *Actaeon*. Both were vintage Manship: sensitive figurative representations, full of movement, with a touch of Art Deco detail. For me, they were an appropriate complement to the sculptures placed so carefully amidst the trees and plantings of the Jacqueline Kennedy Garden.

Paul Manship (1885–1966). Diana (detail). 1921. Bronze with marble base, 36⅞ x 26¾ x 11⅝". The Minnesota Museum of American Art, St. Paul

Paul Manship (1885–1966). Actaeon. 1923. Bronze with marble base, 30½ x 32 x 11¾". The Minnesota Museum of American Art, St. Paul. Bequest of Paul Manship #66.14.103b

The second exhibition opened in April of 1995. A couple of weeks earlier I went to the White House, and I was struck at once by the different character of these works. Most were abstract and concerned forms in relation to space.

The exhibition was organized by Townsend Wolfe, Director and Chief Curator of the Arkansas Arts Center in Little Rock. The works were selected from museums in the Southeast—Little Rock, Louisville, Orlando, Atlanta, Chattanooga, Birmingham, and Washington, D.C.—and were focused on American sculpture from 1965 to the present.

The day was clear and cloudless. I began photographing the sculptures on the south side of the garden, where the morning sun cast a bright light on the long, flat metal arms of the figure called *Adolescence*, by William King. It consisted of rectangular shapes of sheet aluminum and showed a seated figure, hands on knees, his head looking out at the world around him. All of King's works are expressive despite their simplicity, and here one sensed shyness, expectation, hope, idealism, and perhaps the anticipation of growing up and becoming involved in the affairs of the world.

William King (born 1925). Adolescence. *1982. Cast and plate aluminum, 105 x 39 x 86". Hunter Museum of American Art, Chattanooga, Tennessee: Gift of Sara Jo and Arthur J. Kobacker in honor of Abe and Bertha Borisky*

Mark di Suvero (born 1933).
Pollock's Indians. 1976.
Painted steel, 57¼ x 62¼ x 48″.
The J.B. Speed Art Museum,
Louisville, Kentucky: Gift
of the New Collection with
Additional Funds from the
National Endowment
for the Arts

Nearby was *Pollock's Indians,* a remarkable figure by Mark di Suvero. I had long been an admirer of Di Suvero's monumental works at the Storm King Art Center, where large steel beams, combined in a variety of angular forms, looked like futuristic beings standing on the earth and pointing to the sky. This was different. To my camera eye, the sculpture looked like an intricate drawing with curves and squares that seemed to complement and even echo the bare branches of trees in the background. At the base, there was a collection of chains and forms that added a note of mystery to the sculpture.

Boaz Vaadia, who created the sculpture *Zur with Dog*, was born in Israel and studied at the Pratt Institute and the Brooklyn Museum Art School. The life-size figures were made of a series of horizontal forms laid atop one another. The overall impression was of contained solidity. The iconic human figure, which had no facial features, arms, or legs, looked like a bulging tower, while the dog appeared very big by comparison and stood by obediently, as if ready to move on command.

Boaz Vaadia (American b. 1951). Zur with Dog, 1989. Bronze and stone, 49 x 41 x 29". Norton Gallery of Art, West Palm Beach, Florida. Gift of Selma P. Robinson, 92.16

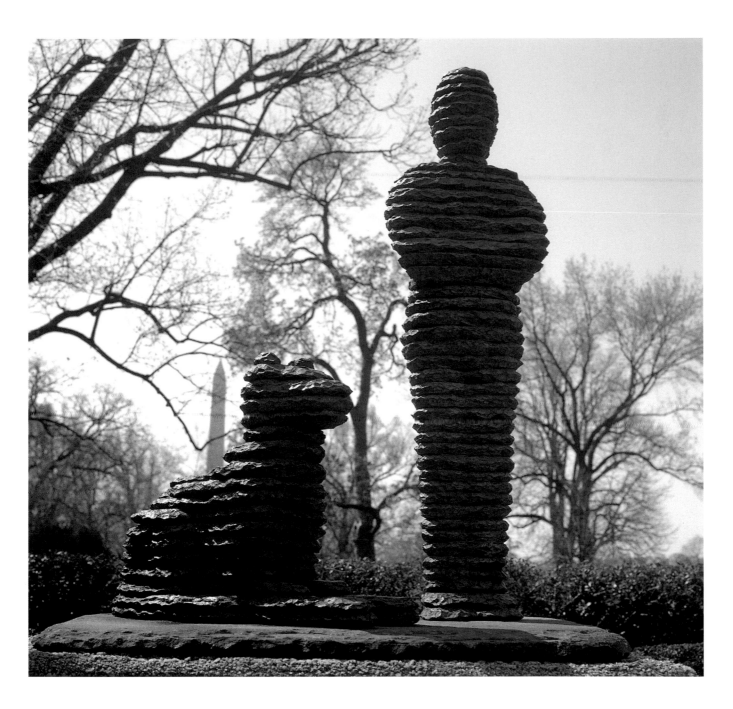

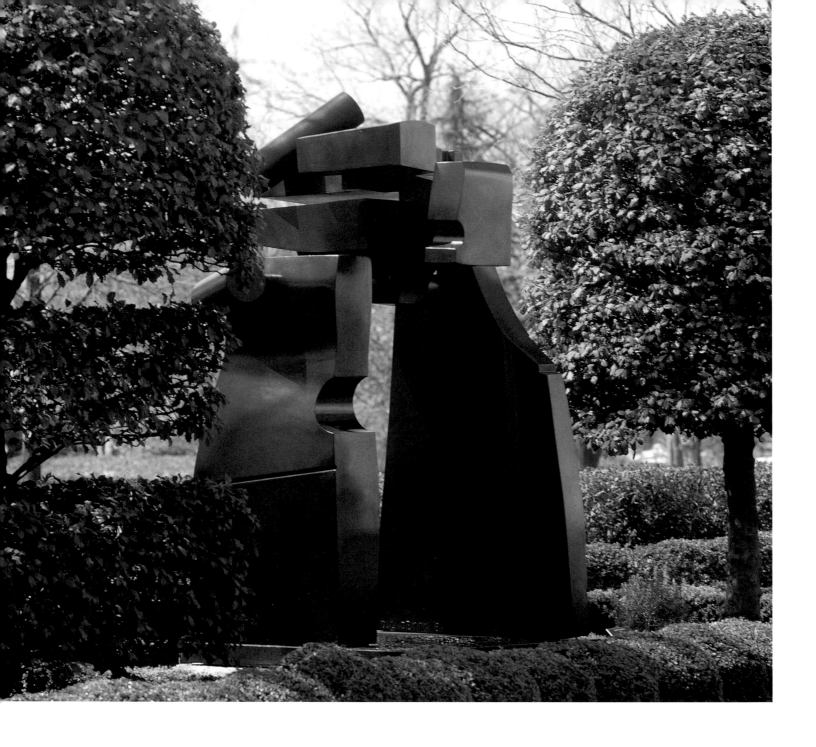

David Deming (born 1943).
Defender. *1986. Painted steel,*
96 x 48 x 48". The Arkansas
Arts Center Foundation
Collection, Little Rock,
Arkansas: Gift of Frank
Ribelin, Dallas, Texas

David Deming's sculpture, *Defender*, was a robotic form. A very large piece rising some eight feet above the ground, it stood in a corner of the garden as if guarding the entrance. Its upper portion consisted of a complex interplay of forms that made interesting compositions as I moved around it with my camera. Oddly enough, while the exhibition was in place a man was caught running toward the garden and stopped about 20 feet short of the sculpture, amusing the artist and convincing him that his work was doing its job defending the White House.

At the east end of the garden David Smith's superb *Cubi XXVI* was supposed to be

installed, but unfortunately it had not yet arrived when I was photographing. I was

asked to shoot it at the National Gallery of Art instead, but it was in a somewhat

cramped space, where I found it impossible to do the work justice. I never did have

a chance to photograph it in the Jacqueline Kennedy Garden, but much later, when

it became part of the new sculpture garden west of the National Gallery of Art, I was

at last able to do so. There, on a bright sunny day, I photographed this glorious

work with all the marvelous highlights glistening on its polished steel surfaces.

The forms jutted out from each other in a superb composition, and photographing

its many different sections was a great adventure.

David Smith (1906–1965).
Cubi XXVI. *1965. Steel,*
119 1/2 x 151 x 25 7/8".
National Gallery of Art,
Washington, D.C. © Estate
David Smith / Licensed
by VAGA, New York, NY

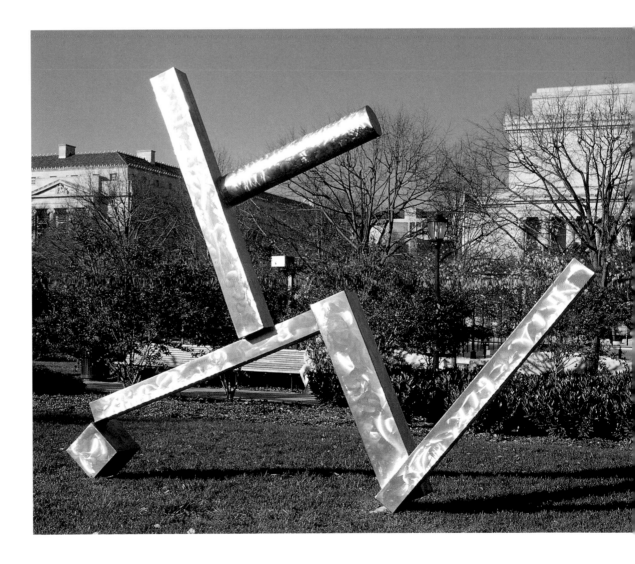

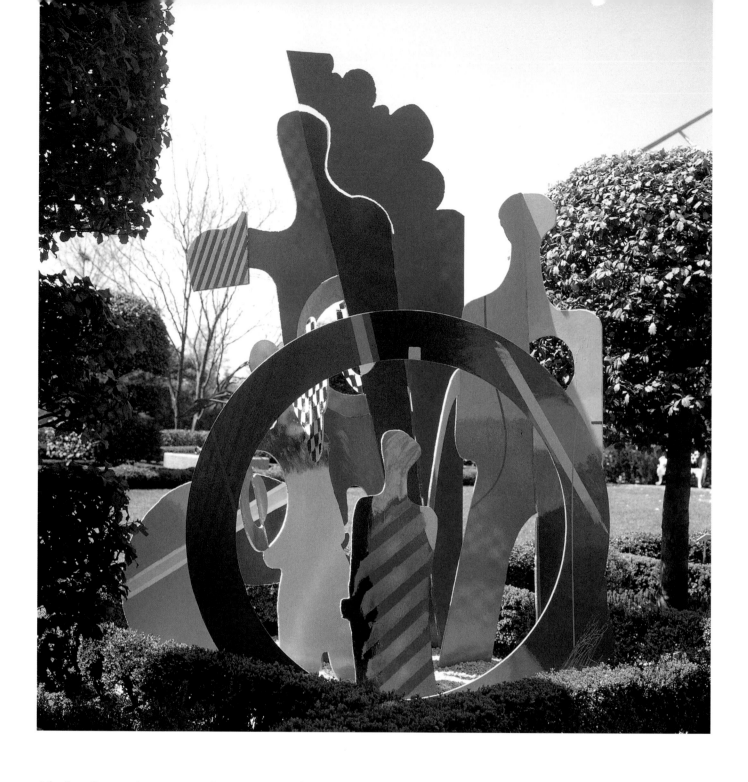

John Scott (born 1940).
Target I. *1993. Polychromed
welded steel, 116 x 75 1/2 x 65".
The Birmingham Museum
of Art, Birmingham,
Alabama: Gift of the artist
in honor of Robin Wade and
the Junior Patrons of the
Birmingham Museum of Art*

Coming around to the north side, there was John Scott's *Target 1.* The only element
reminiscent of a target was the round circular form; otherwise the sculpture was
filled with a variety of brilliantly polychromed steel forms. Some of the cut-out
elements resembled human figures, others were simply abstract shapes. All were
decorated with lines or dots or flat areas of color that gave an exuberant feeling
of lively activity.

Next was an assemblage by Lonnie Holley called *Leverage*. It was made of concrete, found wood, paint, and straw. The wood had a weathered patina and was held in place by a vise, perhaps tightened by a lever. Considered one of the foremost African-American folk artists, Holley was one of 27 children and attended school only through the seventh grade. He ran away from a foster home at the age of 14. After the death of two nieces in a house fire, he was so devastated that he attempted suicide, but subsequently expressed his grief by making the tombstones his sister could not afford to buy for her children's graves. After that, at the age of 29, he began making sculptures out of found objects. He thought of *Leverage* and other sculptures as a way of sending a message against "the cruel and the bad."

Lonnie Holley (born 1950). Leverage. *1993. Concrete, found wood, paint, straw, 79½ x 45½ x 17".* *The Michael C. Carlos Museum, Emory University, Atlanta, Georgia: Gift of William S. Arnett*

Beverly Pepper (born 1924).
Ternana Altar II. *1991. Cast iron with fabricated steel base, 92 ³⁄₈ x 47 ¼ x 26 ⁵⁄₈".
National Museum of American Art, Smithsonian Institution, Washington, D.C.: Gift of the artist and museum purchase made possible by J.B. Chadwick.*
© 1991 Beverly Pepper

Beverly Pepper's cast-iron *Ternana Altar II* is an inventive sculpture consisting of curved planes that create a graceful abstract form. The cut groove narrows as it rises to the top and acts as a counterpoint to the shapes on each side, in which an arrow comes to a point. Like many of the artist's other sculptures, this work has a presence that gave vibrant life to the air around it in the White House installation.

Vertical Void by Carol Hepper is made of copper and steel tubing that curve in and out of each other to create a continuous spiral. The forms and the spaces within change as the viewer moves around the sculpture. An ingenious composition, this proved to be one of the most popular sculptures in the exhibition.

Carol Hepper (born 1953). Vertical Void. 1994. Copper and steel, 58 x 47 x 52 . The Orlando Museum of Art: Acquisition Trust Purchase, 1994

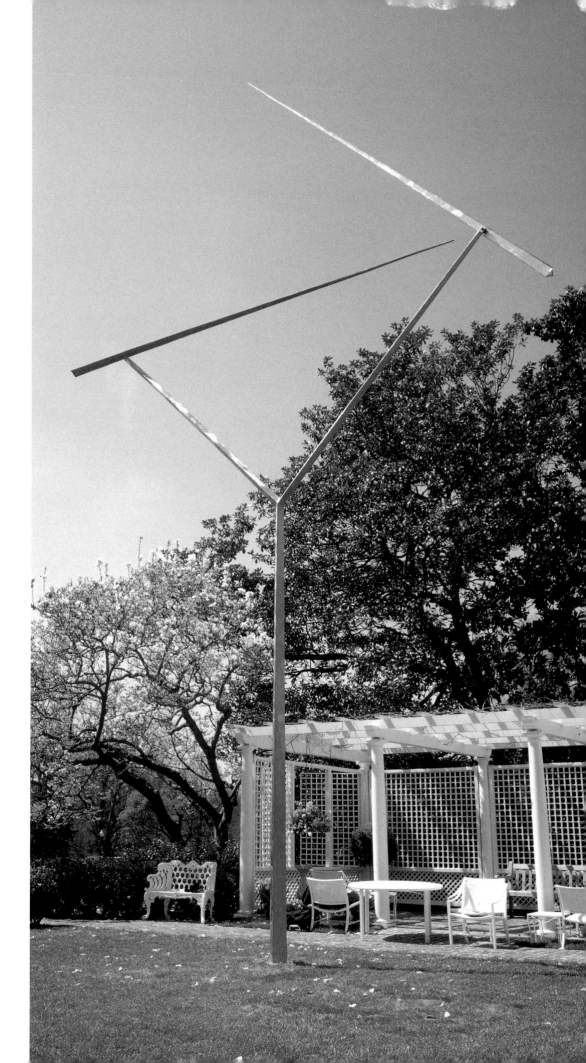

George Rickey's *Two Lines Oblique, Atlanta*, looked grand standing at the west end of the garden and waving its arms against the clear blue sky. There was a slight wind the day I was there, and the stainless steel pointers were a delight to watch as they alternately crossed each other and moved apart in slow motion. Some parts shone brightly in the sun while others were in shadow, creating a constantly changing composition.

George Rickey (born 1907). Two Lines Oblique, Atlanta. 1969. Stainless steel, height 35'. High Museum of Art, Atlanta, Georgia: Gift of Mr. and Mrs. Simon S. Selig Jr. in memory of Mr. Ben Massell with the generous cooperation of the artist and Staempfli Gallery. © George Rickey / Licensed by VAGA, New York, NY

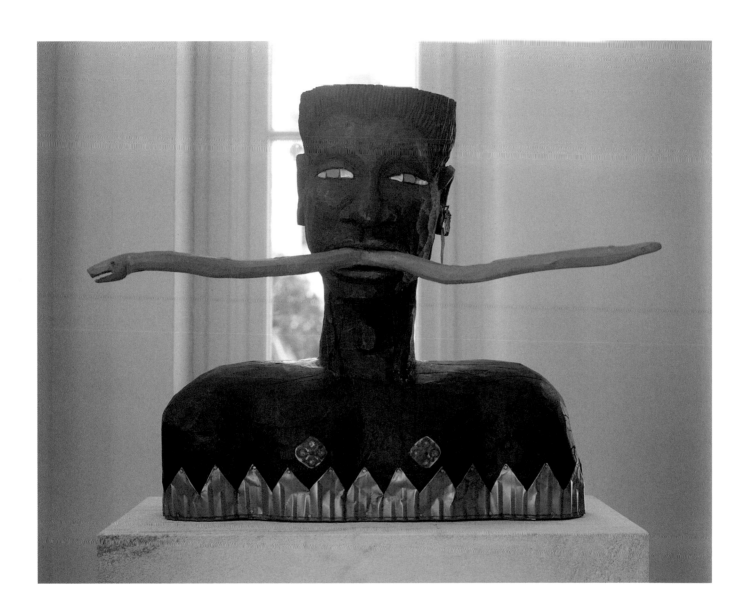

Alison Saar (born 1956).
Snake Charmer. *1985.*
Painted wood, medals,
ceramic, glass, and mother
of pearl, 21 x 26 x 14".
Hirshhorn Museum and
Sculpture Garden,
Smithsonian Institution,
Washington, D.C.: Partial
gift of Merry Norris
and Museum Purchase

Inside the White House was a strange sculpture by Alison Saar titled *Snake Charmer*. The figure's eyes seemed to glow with an inner light. The green decoration on the base of the figure looked like a metallic garment, the gold ornaments on the chest were like jewels, and the flat hat like that of a sorcerer. One could almost feel the snake being charmed by supernatural powers as the sculpture stood quietly against the window.

Across the way was a sensitive *Mother and Child* by Elizabeth Catlett, carved out of rich mahogany. As with her other works, the figures seemed to show their inner feelings in their relation to one another. Here one could sense the warmth of the mother's love as her protective arms held the child, and sense her pride in the tilt of her head. One could be charmed by the wonder in the eyes of the child. There was something captivating in the graceful lines of the figure, and I discovered many beautiful images as I moved around with my camera and looked at it from different angles through my viewfinder.

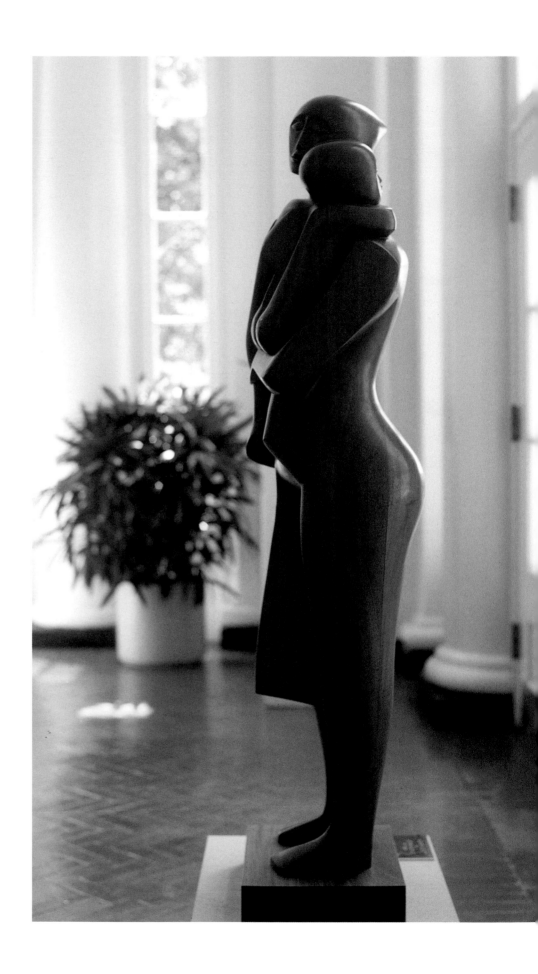

The first sculpture I
photographed was William
Tucker's *Track*. Fortunately,
it was placed in a corner of
the garden, so that its sparse
forms could be seen against
a striking view of the
landscape. The triangular
negative space created by the
forms seemed as important
as the forms themselves,
and in that site they looked
like a frame or accent for
the foliage behind them.
The three slightly angled
parts of the hypotenuse in
the triangle gave the figure a
softness that was especially
appropriate in that setting.

*William Tucker (born 1935). Track.
1981. Mild steel, 93 x 24 x 84".
The Denver Art Museum: Gift of
Mr. and Mrs. Richard Miller. 1995.4*

The third exhibition opened in October 1995, and this time when I arrived
to photograph the sculptures, the sky was overcast. All the sculptures
in the garden were abstract, and they were quite different from those in
previous exhibitions. The curators were Peter C. Marzio, Director, and
Alison de Lima Greene of the Museum of Fine Arts, Houston, who chose
works from museums in the Southwest and West.

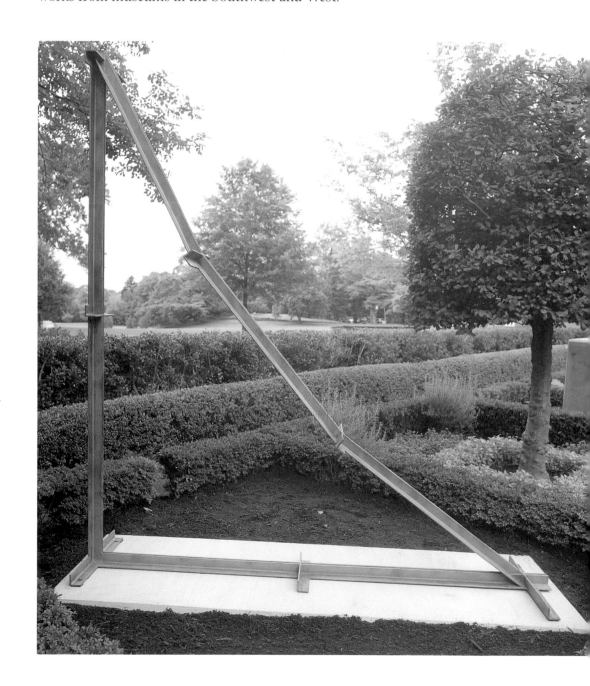

Jesús Bautista Moroles's *Moon Ring 3*, in Texas granite, demonstrated a remarkable technical virtuosity. The jagged forms of the material gave it a rich texture rarely found in stone sculptures. The three round spaces resembled the moon, while the two horizontal stones at the center provided the ring around the moon.

Jesús Bautista Moroles (born 1950). Moon Ring 3. 1982. Texas pink granite, 79¼ x 46 x 16". The Old Jail Art Center, Albany, Texas. 82.053

No Title, Robert Therrien's bronze sculpture, was a simple, black form rising from a circle in the ground, tapering as it moved upward and bending at an angle toward the top where it came to a point. Without a title there was no hint as to its implicit meaning, and viewers were left to respond to the form. On this gray day, with its overcast sky, I felt there was something obscure about the form, as if it held some deeply hidden secret that we could never know.

Although Georgia O'Keeffe's paintings rank among the great achievements of American painting in the twentieth century, it was surprising to see a sculpture by her. Yet the white, lacquered bronze called *Abstraction* was clearly recognizable as part of her oeuvre. The sensuous, curving lines were like one of her magnificent flowers, with the suggestive opening in the center and the soft fleshy forms surrounding it so gracefully. It was, in effect, a painting in three dimensions.

Georgia O'Keeffe (1887–1986). Abstraction. 1945/1978–80. White lacquered bronze, 36 x 36 x 18". The Georgia O'Keeffe Foundation, Abiquiu, New Mexico. © 2000 The Georgia O'Keeffe Foundation / Artists Rights Society (ARS), New York

A Deborah Butterfield horse titled *Hina* was placed at the east end of the garden. A noble animal, it stood sturdily on its four legs, head bent as if pausing momentarily to consider its next move. The bronze casts of twisting branches that are Butterfield's hallmark made fascinating compositions in details as well as from different views. The wires wound together to make the forms, and the spaces created in between were as important to the impact of the sculpture as the jagged lines that created them.

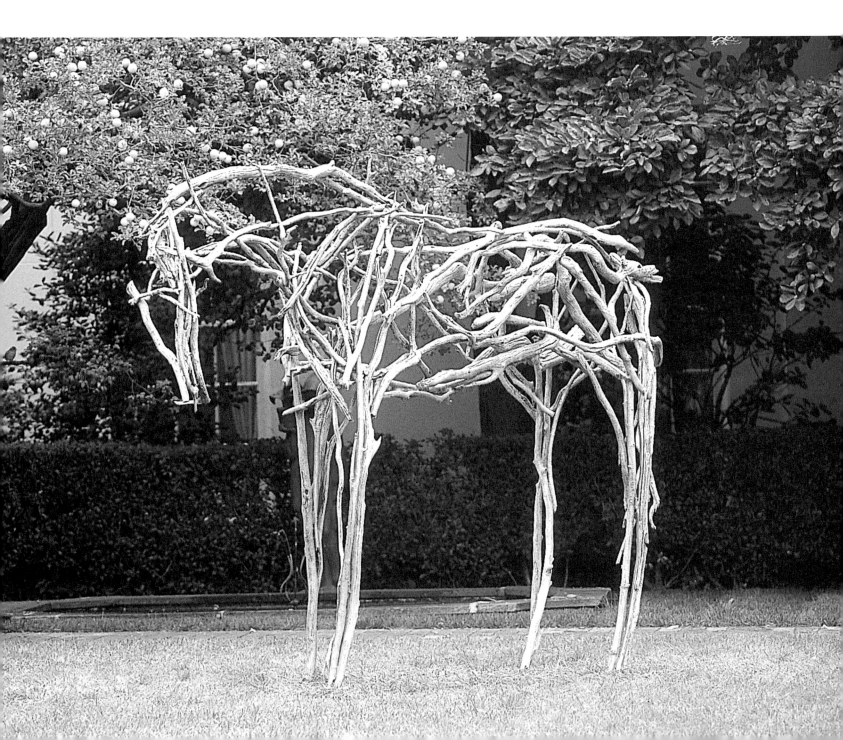

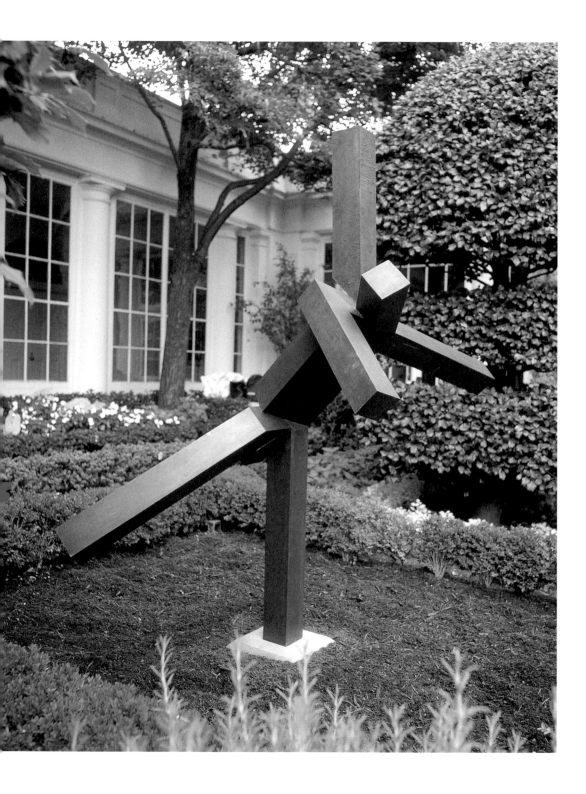

A Joel Shapiro rectangular figure, *Untitled*, could be seen against the windows of the White House corridor in the background. The jutting forms suggested tension and strength, perhaps like a dancer. The tilted head added a critical accent to the figure, as if to give it a special meaning. All the elements were composed with a great sense of balance not only in the forms, but in the forces they seemed to represent.

Joel Shapiro (born 1941). Untitled. 1982. Bronze, 72 x 70 x 30". The Museum of Contemporary Art, Los Angeles: The Barry Lowen Collection

Exhaling Pearls, by Joseph Havel, is an unusual amalgam of forms. Two white balls, one on top and one on the bottom, cast into bronze from Japanese lanterns, are connected by a bronze cast of a braided rope that curves from one to the other. It is an imaginative and original creation that seems to defy natural laws and makes a statement about the nature of reality that has to be felt rather than understood. The holes in the lanterns seem to imply the existence of some secret entrance to the inner being of the sculpture.

Joseph Havel (born 1954).
Exhaling Pearls. 1993.
Patinated bronze, 130 x 55 x 33".
The Museum of Fine Arts,
Houston: Museum purchase
with funds provided by the
Caroline Wiess Law Accessions
Fund, Isabell and Max
Herzstein, Isabel Wilson,
Nona and Richard Barrett,
and friends of the artist

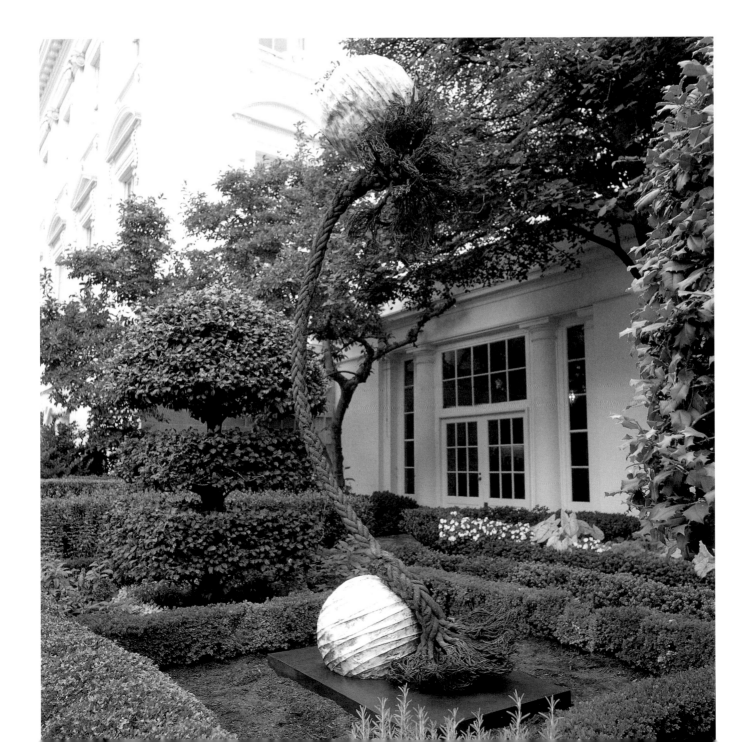

Martin Puryear (born 1941). Decoy. 1990. Cast iron, 40 1/4 x 110 1/2 x 109 1/2". The Los Angeles County Museum of Art: Purchased with funds provided by the Art Museum Council and the Flintridge Foundation

Decoy, by Martin Puryear, was placed in the middle of the garden and created a provocative, startling presence. The large bronze oval lying flat on the ground was simple in itself, but then there was that strange form coming out of it at one end. The form had an organic quality, like a centipede, but there was also something mechanical about it, as if it was a device in which parts fitted within other parts and could be stretched out to form a curve. Puryear, who studied with craftsmen in Sierra Leone when he was in the Peace Corps, and later studied in Sweden, eventually receiving a Master of Fine Arts degree from Yale, has developed a unique approach to creating objects from imagination that have a life of their own.

In the small garden arbor where a table and chairs were usually placed was Scott Burton's *Granite Settee*, an abstract composition consisting of rectangular blocks of different sizes. It looked in a way like an artist's conception of a bench, which seemed especially appropriate in that place, especially since I could photograph it in front of the grid made of wood slats in the back.

Scott Burton (1939–1989). Granite Settee. 1982–83. Granite, 36 x 65 x 35". Dallas Museum of Art: Purchased through a grant from the National Endowment for the Arts with matching funds from Robert K. Hoffman, the Rohlee Corporation, Laura L. Carpenter, Nancy M. O'Boyle, and an anonymous donor, 1983

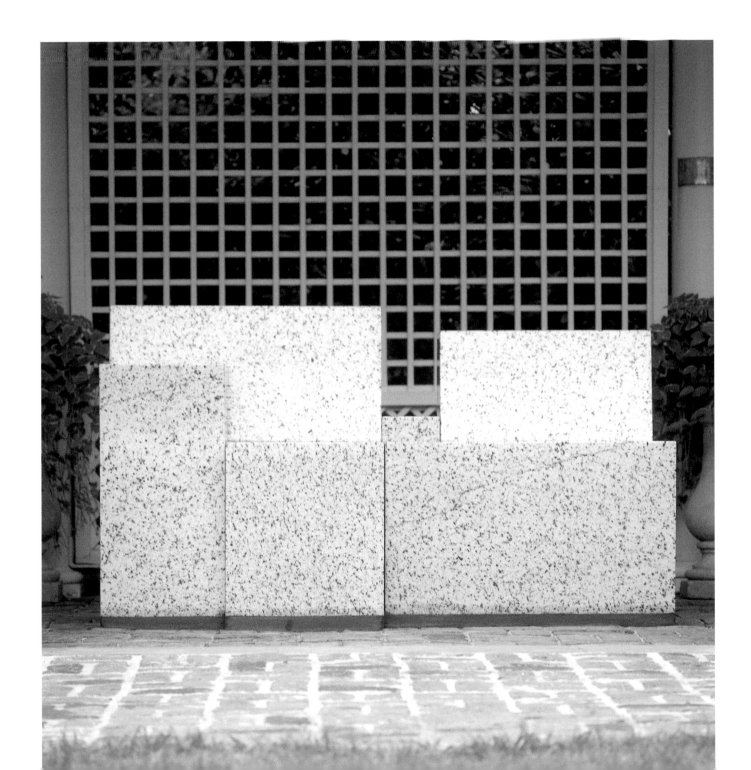

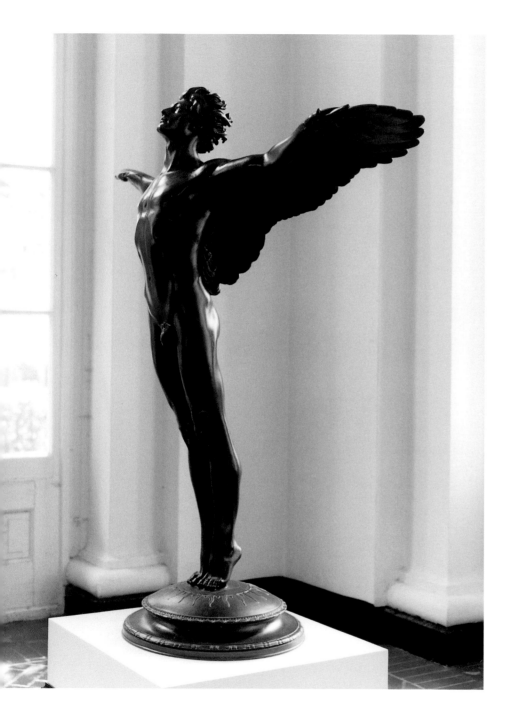

Indoors, there were two sculptures by Adoph Weinman—*Rising Sun* and *Descending Night*. Neoclassical works produced in 1915 and somewhat typical of their time, they provided a contrast to the works installed in the garden. But they also made a statement about the continuity of creative expression, because the imagination that led to these works was of the same order of creativity as the sculptures outside.

Left: *Adolph Weinman (1870–1952).* Rising Sun. *1915. Bronze, 57 x 53 x 19½". The Museum of Fine Arts, Houston: Anonymous gift*

Opposite: *Adolph Weinman (1870–1952).* Descending Night. *1915. Bronze, 54 x 54 x 19". The Museum of Fine Arts, Houston: Anonymous gift*

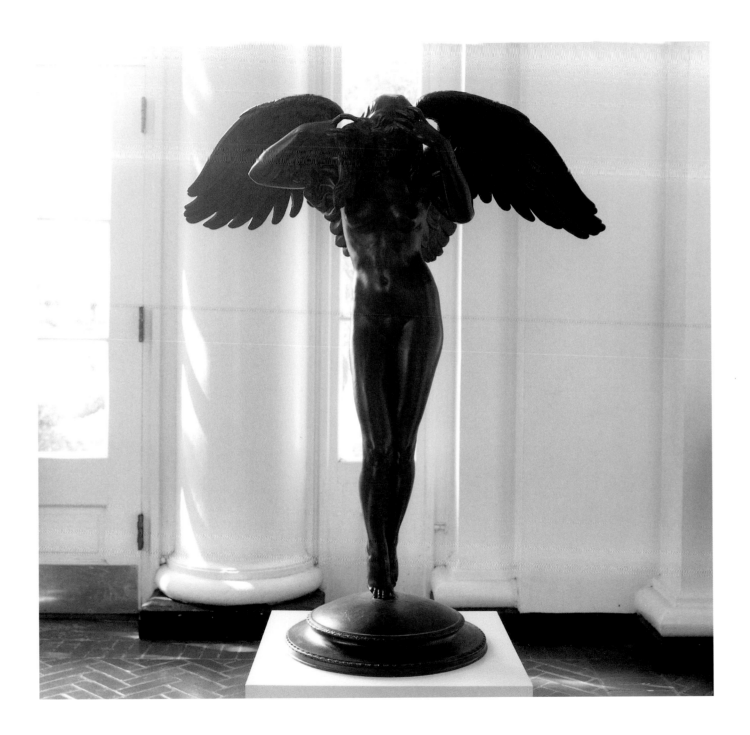

4

The fourth exhibition, which opened in October 1996, featured works from museums in the Northeastern region of the United States and was organized by Marcia Tucker, Director of the New Museum of Contemporary Art in New York. All the sculptures were made after 1971, most within the previous decade. Some were by well-known artists and others were by younger sculptors just at the early stages of winning recognition.

I began photographing in the southwest corner of the garden as usual. There, Maren Hassinger's *In a Quiet Place* could be seen against a gray sky. The wire, rope, and concrete shoots springing up from the ground were like a newly made forest. It was not a sculpture that invited the camera to focus on interesting details; rather, it was a conceptual piece that conveyed the idea of contemplation when seen in its entirety.

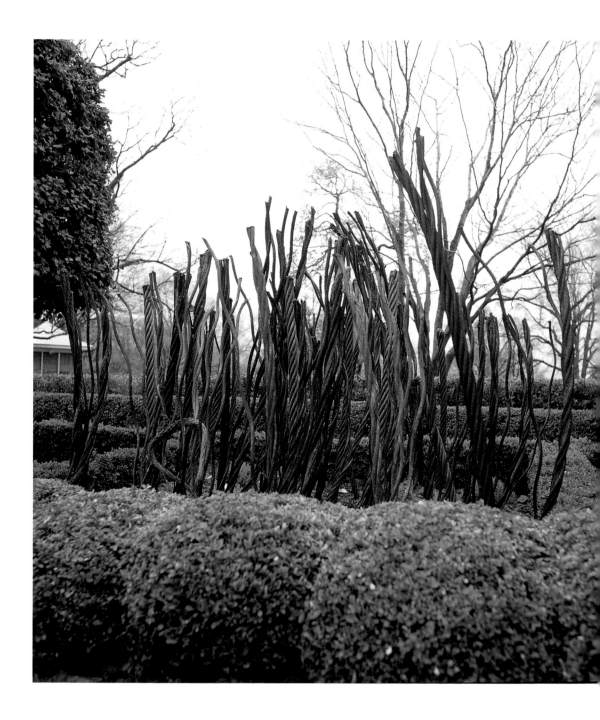

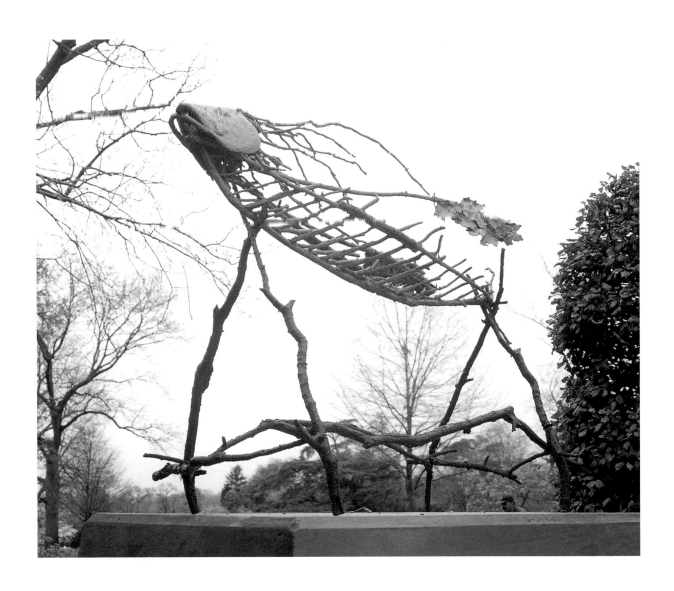

Ed Shay's *Acadian Gyro* used bronze casts of limbs of trees very much as Deborah Butterfield did in her sculptures, but with a different purpose in mind. Here they provided a lifelike base to the skeletal figure above. There was something noble about the figure, with the face of the fish looking upward while the remains of its body lay as a grisly fragment on the mounted sticks.

A brighter note was struck with *Stiff Box No. 12* by Lucas Samaras. Here a purely decorative arrangement of lines in space seemed almost musical in its elegant composition. Samaras uses a variety of materials in many of his other sculptures, always with great imagination and flair, but in this work there are only simple bronze shapes that twist and turn and cross each other as they surround the small geometric forms in the center.

Lucas Samaras (born 1936). Stiff Box No. 12. 1971. Cor-ten steel, 75½ x 55½ x 14". Solomon R. Guggenheim Museum, New York: Gift in honor of Mr. Martin Fisher, 1971

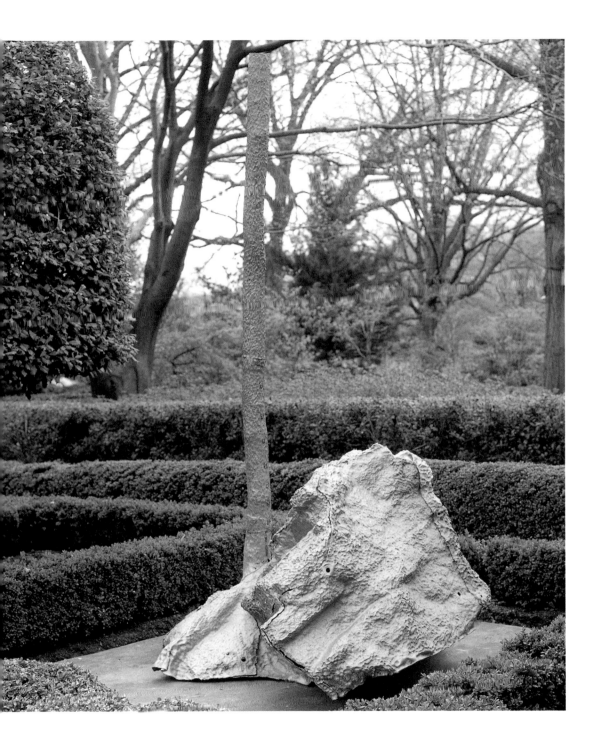

Robert Lobe (born 1945).
Harmony Ridge #26. *1990.*
Anodized hammered
aluminum, 94 x 57 x 49 1/2".
The Brooklyn Museum of
Art, Brooklyn, New York:
Purchased with funds given
by the National Endowment
for the Arts Museum
Purchase Plan and Gift
of Edward A. Bragaline,
by exchange

Harmony Ridge #26 by Robert Lobe is made of anodized hammered aluminum.

To gain the desired effect, the artist used hand and power tools to hammer

out aluminum sheets and rivet them together. The sculpture looks like a metal pole

mounted on a rock, or it could be the trunk of a tree on a mountain. In any case,

it seems true to nature rather than abstract.

Melvin Edwards (born 1937).
Gate of Ogun. *1983. Stainless*
steel (2 parts), 96 x 144 x 48".
Neuberger Museum of Art,
Purchase, New York:
Purchase College, State
University of New York,
museum purchase

Melvin Edwards's stainless steel *Gate of Ogun* filled the space at the east end of

the garden. Although simple in concept, there was a quality about its design

reminiscent of ancient structures like Stonehenge. The highlights in the polished

steel, which would have been more distinctive with the sun shining on them,

gave a textured quality to the surface. The combination of forms in the center

created intriguing compositions from almost every angle.

In the northeast corner of the garden was Joel Fisher's *Seed (Egg Man)*. The figure, in rough textured bronze, could be seen rising out of the giant seed with its smooth surface. It was a surreal conception, and I was lucky to be able to photograph it from an angle that juxtaposed its forms with those of a tree in the background. The windows of the White House, also seen in the background, created an environmental setting that somehow seemed appropriate.

Joel Fisher (born 1947). Seed (Egg Man). 1986–87. Bronze, 39½ x 28¾ x 22". The Museum of Modern Art, New York Gift of Agnes Gund. Photograph by David Finn, © 2000 The Museum of Modern Art, New York

Then there was *Repugnant Rapunzel* by Chakaia Booker. This colorful yet somewhat forbidding work was made of rubber tires, wood, and metal. Parts of it were painted bright orange, giving it a lively quality, while other parts were dark and gloomy. The combination of textures and forms seemed organic, but unlike anything that might be seen in nature, gave it the appearance of some supernatural being.

Chakaia Booker (born 1953). Repugnant Rapunzel (Let Down Your Hair). *1995. Rubber tire, wood, metal, 33 x 25 x 24". The Studio Museum in Harlem, New York: Gift of the friends and family of Chakaia Booker, 1996*

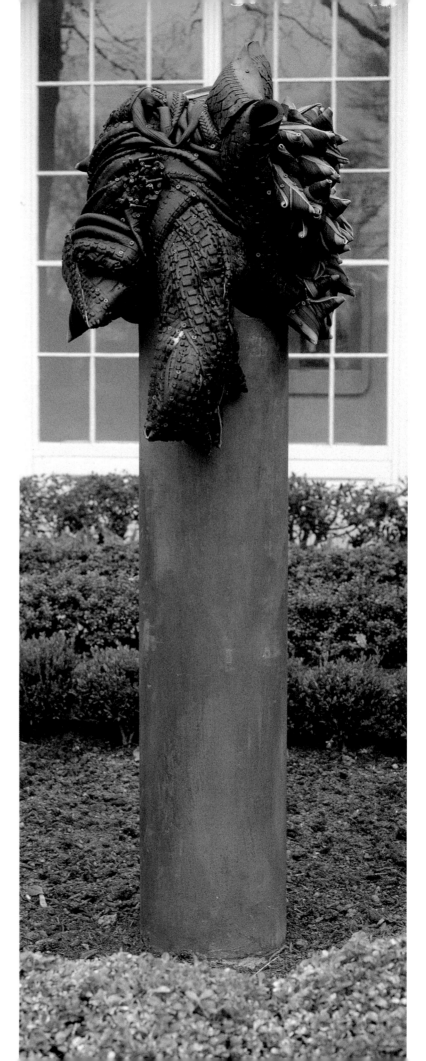

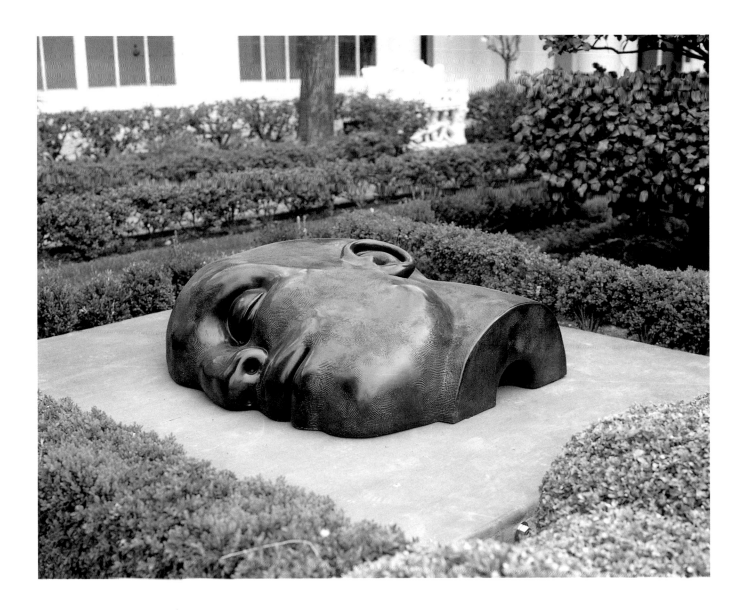

The Head, by Tom Otterness, lay flat on the ground on a concrete base. It was a naturalistic portrait, but like so many of his works there was a peculiar aspect that gave it an unusual character. In this case, it was that the head, large enough to have been part of an enormous monument, was lying on its side like a relief coming out of a wall that was horizontal rather than vertical. As I faced my camera down to get a good shot, I felt that creating a sense of disorientation may have been one of the artist's aims.

Tom Otterness (born 1952).
Head. 1988–89. Bronze,
14¾ x 38¼ x 46¾". The
Museum of Modern Art,
New York: Acquired with
matching funds from
the Louis and Bessie Adler
Foundation, Inc. and the
National Endowment
for the Arts, and purchase.
© Tom Otterness / Licensed
by VAGA, New York, NY.
Photograph by David Finn,
© 2000 The Museum of
Modern Art, New York

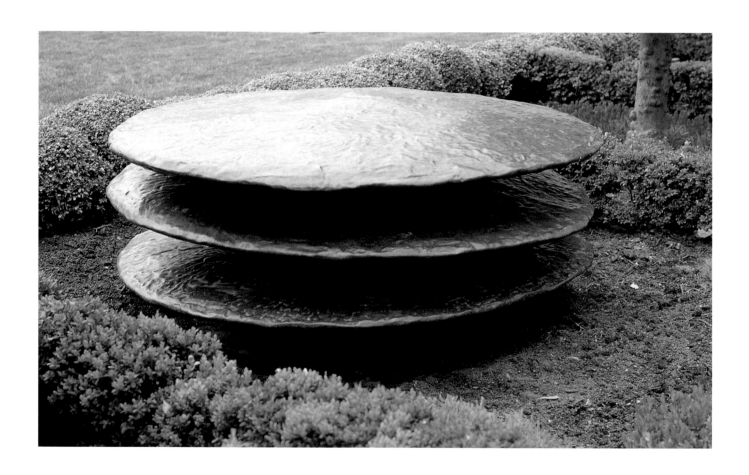

Only slightly higher than the hedges that surrounded it, *Triple Disc Bronze* by Mia Westerlund Roosen was set directly on the ground rather than on a base. The painterly texture on the surface of the bronze produced a special richness, and the spacing of the discs several inches apart from each other created shadows and highlights that gave the work a floating quality. The structure seemed to be well suited to its site, almost as if it had been created for that space.

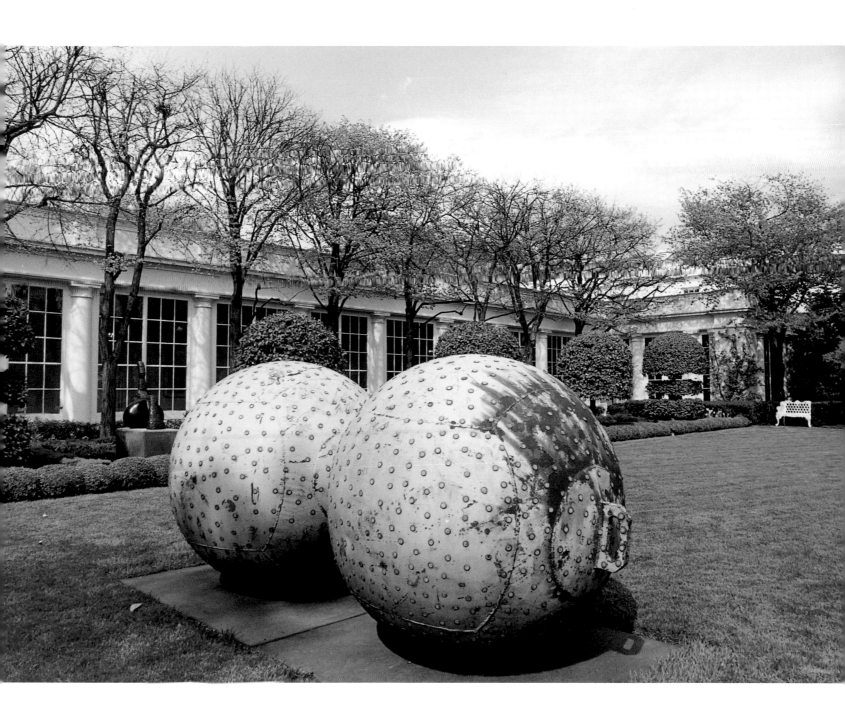

In front of a small garden arbor stood *The West* by Donald Lipski. Two large round balls made of painted steel, corroded pennies, and silicone adhesive rested on a flat base set on the grass. Lipski has often created artworks made of everyday things, including at one time a collection of art materials left over from his Brooklyn studio. Here the sculpture consisted of globes with patterned and free-form decorations.

Donald Lipski (born 1947). The West. 1987. Painted steel, corroded pennies, and silicone adhesive (2 elements), 60" diameter each. The Metropolitan Museum of Art, New York: Purchase, Louis and Bessie Adler Foundation, Inc. Gift (Seymour M. Klein, President), 1988. Photograph by Phil Humnicky

Allan McCollum (born 1944). Perfect Vehicles. *1986. Acrylic and enamel paint on solid-cast hydrocal pedestal, cast objects 20½ x 8 x 8" each, pedestal 42 x 50 x 11". The New Museum of Contemporary Art, New York*

Indoors, there was *Perfect Vehicles* by Allan McCollum. This is one of the repetitive works in which he followed what he called the policy of "working to rule" the way an individual does in a factory. Some of his better-known works consist of a series of picture frames with nothing inside. His work was intended as a "retraction of effort"; instead of producing something by the exercise of creative talent or expenditure of creative effort, he wanted merely to show the product of his labor. In this case he made a series of objects that were exactly the same except for their colors. The work is more of a statement about society than the creation of an aesthetic object.

Also inside was *Dallaleve* by Nancy Graves, which was created as an aesthetic object. It alludes to botanical forms of the artist's own invention. Following the forms of two arcs going in opposite directions, the bronze sculpture has a polychrome patina and enamel that give it a jewel-like quality.

Nancy Graves (1940–1995). Dallaleve. 1984. Bronze with polychrome patina and enamel, 15 x 41½ x 30". Albright-Knox Art Gallery, Buffalo, New York: Gift of Seymour H. Knox, 1987. © Nancy Graves Foundation / Licensed by VAGA, New York, NY

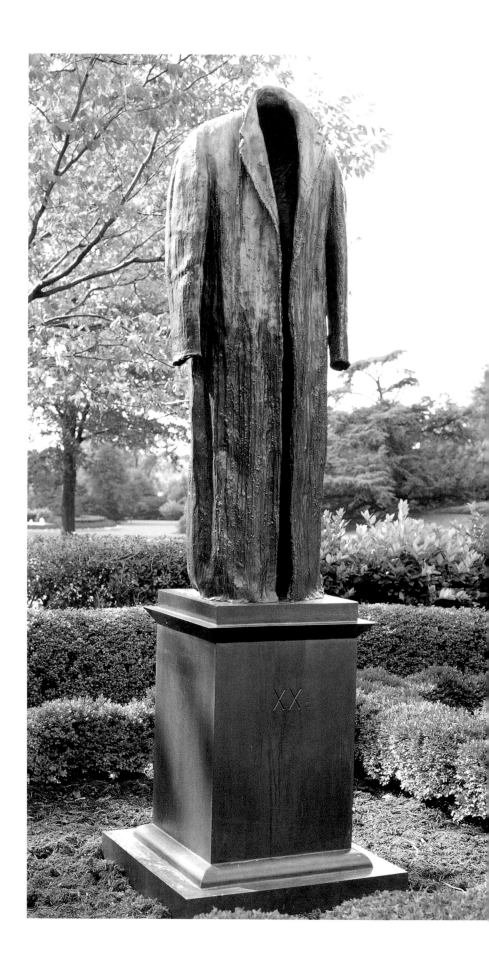

5

The fifth exhibition opened on September 17, 1997. It was selected from public collections in Washington, D.C., and was organized by Earl A. Powell III, the Director of the National Gallery of Art.

I photographed this exhibition on one of those changeable days when I had to adjust my camera settings repeatedly as clouds moved across the sun. I began with Judith Shea's *Post-Balzac*, a curious sculpture of a coat standing by itself without a figure inside. It is a finely worked piece, with vigorous chisel marks on the surface and a rich patina in the bronze. The absence of a man to fill the coat did not seem especially surprising to me, since the form was modeled as if one had been there. However, I had previously watched onlookers when the sculpture was outside the Hirshhorn Museum and noticed their amusement at the oddity of a sculpture of a coat.

David Smith's *Agricola I* is one of his great painted-steel sculptures welded of discarded agricultural implements. As always, it was amazing to see how he had created such exquisite designs by piecing together steel elements made for an entirely different purpose. Magically, he created forms and spaces that seemed to be elements of organic beings. Although the sculpture was not complicated, I explored many of its details with my camera and found them all fascinating.

Opposite: *Judith Shea (born 1948). First Balcony, 1991. Bronze, 98½ x 28½ x 28½". Hirshhorn Museum and Sculpture Garden, Smithsonian Institution, Washington, D.C.: Museum Purchase, 1991*

Right: *David Smith (1906–1965). Agricola I 1951–52. Painted steel, 73½ x 55¼ x 24⅝". Hirshhorn Museum and Sculpture Garden, Smithsonian Institution, Washington, D.C.: Gift of Joseph H. Hirshhorn, 1966*

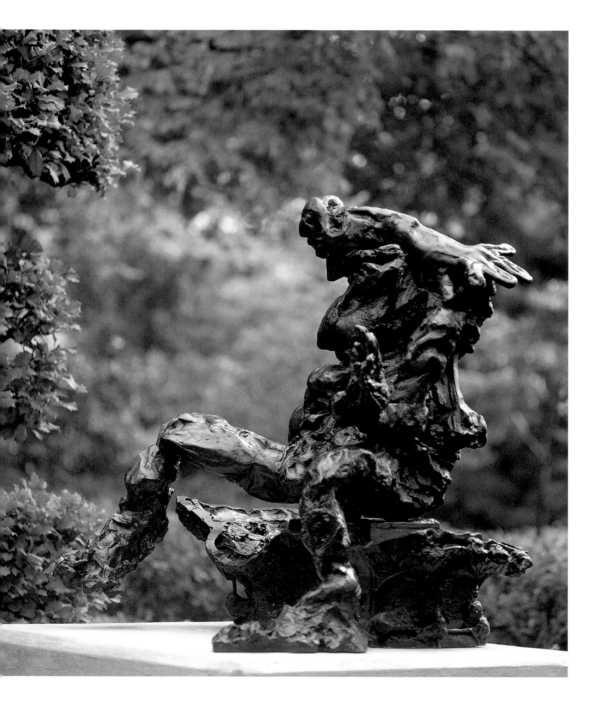

Next came Willem de Kooning's *Seated Woman on a Bench*. As I turned my camera on this sculpture, I felt it was more like a painting in bronze than a three-dimensional work. It had the vigor and dash found in his canvases, rather than the composed forms one would expect in a sculpture. But it provided a focal point as it stood on its pedestal in the garden with colorful foliage in the background.

Willem de Kooning (1904–1997). Seated Woman on a Bench. 1972, cast 1976. Bronze, 37¾ x 36 x 34⅜". Hirshhorn Museum and Sculpture Garden, Smithsonian Institution, Washington, D.C.: Bequest of Joseph H. Hirshhorn. © 2000 Willem de Kooning Revocable Trust / Artists Rights Society (ARS), New York

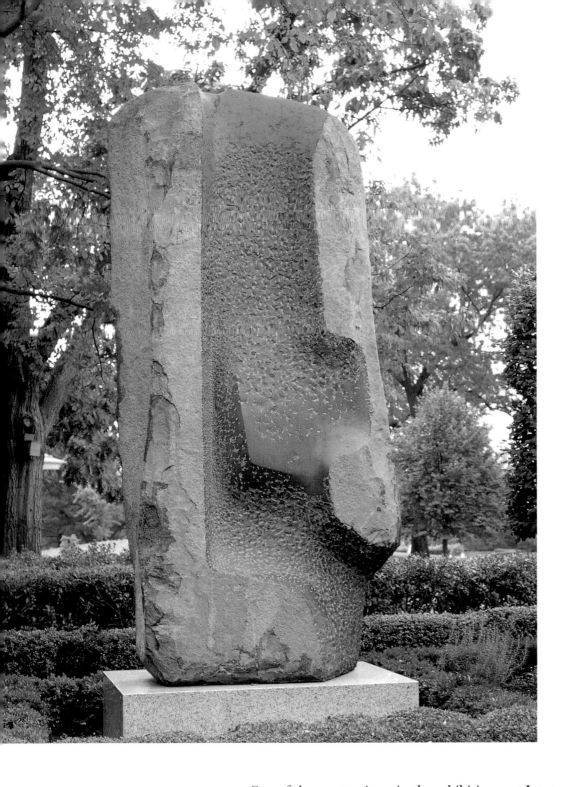

Isamu Noguchi (1904–1988).
Great Rock of Inner Seeking. *1974.*
Basalt, 10′ 7⅞″ x 5′ 2⅜″ x 2′ 11″.
National Gallery of Art,
Washington, D.C.: Gift of
Arthur M. Sackler, M.D. and
Mortimer D. Sackler, M.D.

One of the masterpieces in the exhibition was Isamu Noguchi's *Great Rock of Inner Seeking*. Some years earlier I had photographed this same sculpture when it stood outside the East Building of the National Gallery of Art, and I had written an article about it for *Roll Call*, the newspaper of the Congress. I had been mesmerized then, and I was moved once again when I photographed the work as part of this exhibition. The variety of forms and textures in the basalt stone was breathtaking.

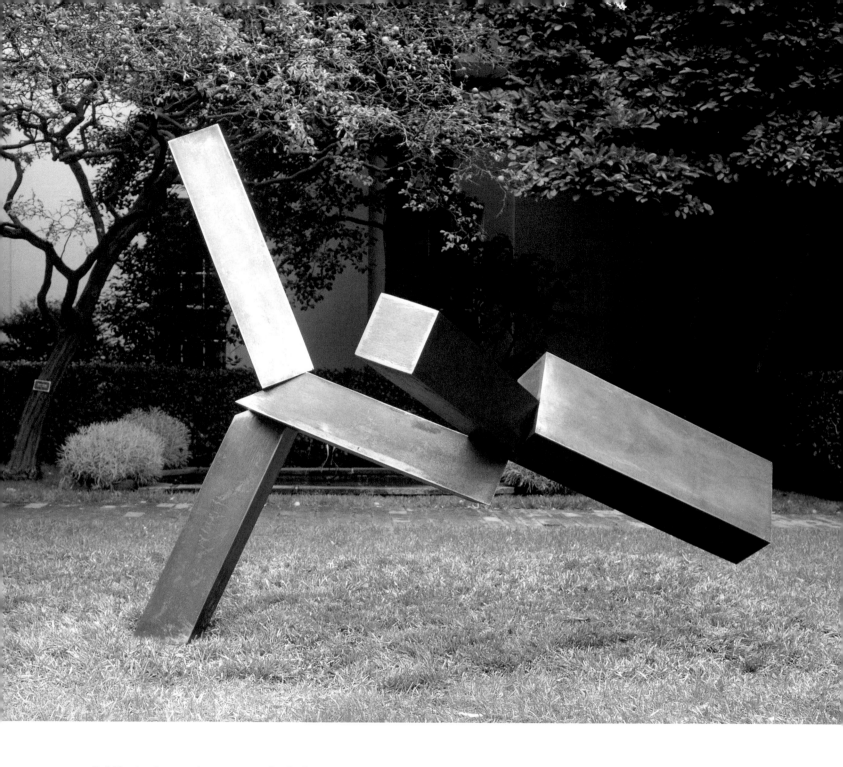

Joel Shapiro (born 1941).
Untitled. 1989. Bronze,
65 x 77 x 62½". National
Gallery of Art, Washington,
D.C.: Gift of the Collectors
Committee, 1990

I had photographed one of Joel Shapiro's *Untitled* sculptures in the third exhibition, and now here was another. This time the figure, made of rectangular blocks, was resting on an upright support, its body flung backward to gain balance and its feet thrust forward exuberantly. All of Shapiro's sculptures have similar elements, and his figures resemble each other in style and conception; yet each makes an individual statement through its unique position and stance.

By contrast, Richard Hunt's *Large Hybrid* was quite different from other sculptures of his that I had photographed. The piece in the first White House exhibition was made of flat cut-out pieces of Cor-ten steel; this one was a bronze sculpture of biomorphic forms. It resembled a being from outer space with head, arms, and body vastly different from those of the earthbound human.

Richard Hunt (born 1935). Large Hybrid. 1971. Bronze, 100½ x 42 x 25¼". Hirshhorn Museum and Sculpture Garden, Smithsonian Institution, Washington, D.C.: Gift of Max Robinson, 1984

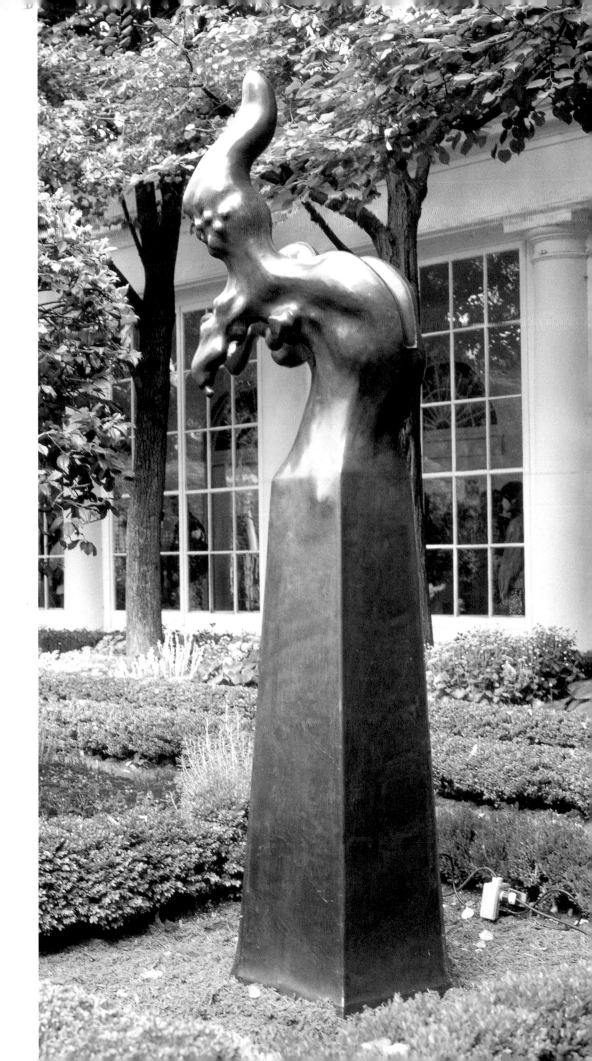

The Alexander
Archipenko sculpture
Le Gondolier is a classic
figure in a tradition
dating back to the
mid-twentieth century.
Its Cubist forms create
a well-balanced figure
easily recognizable
as being in his unique
style. As I photo-
graphed, views from
different angles
revealed surprising
elements that showed
both the unity and
complexity of the work.

*Alexander Archipenko
(1887–1964). Le Gondolier.
1913–14, reconstructed c. 1950,
cast 1957–58. Bronze, ed. 2/6,
72 x 24¾ x 15½". Hirshhorn
Museum and Sculpture
Garden, Smithsonian
Institution, Washington,
D.C.: Gift of Joseph H.
Hirshhorn, 1966. © 2000
Estate of Alexander
Archipenko / Artists Rights
Society (ARS), New York*

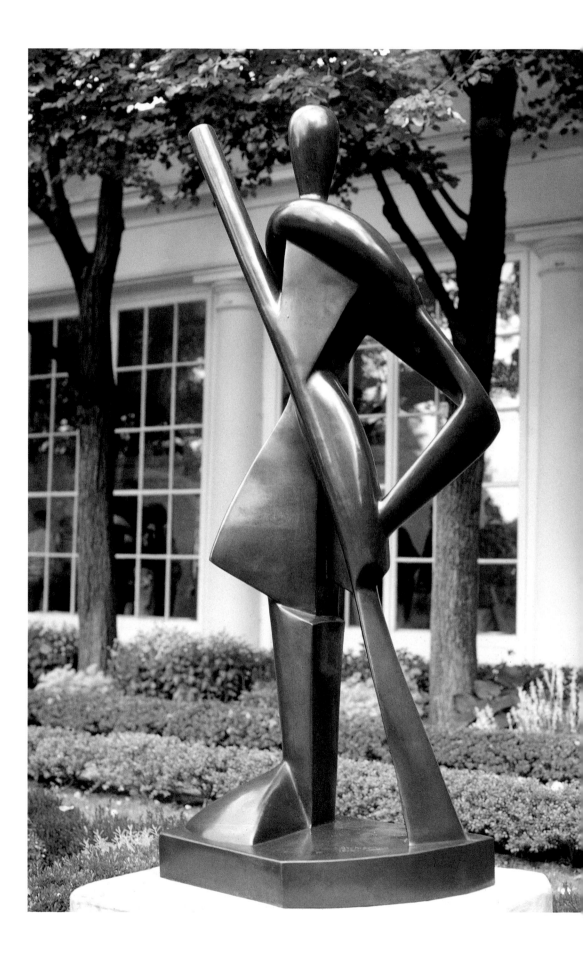

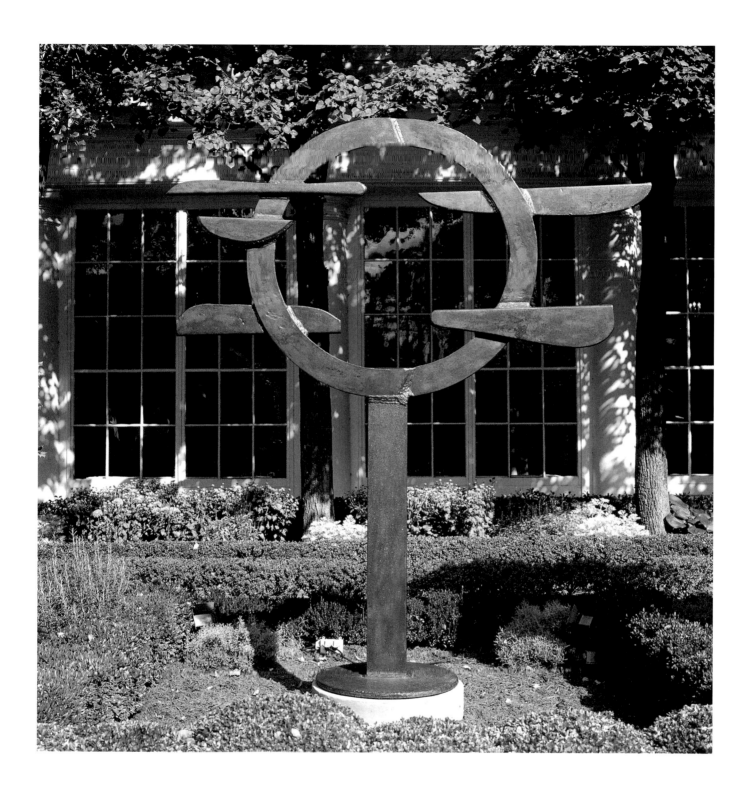

The second David Smith sculpture in the exhibition was *Voltri XV*. This, too, is a welded-steel composition made of found objects. It is not as clear in this work where the parts came from, but again the forms are brilliantly composed and the spaces within the forms seem to pulsate with vital energy.

David Smith (1906–1965). Voltri xv. *1962. Steel, 89 ⅞ x 77 ¼ x 22 ⅝". Hirshhorn Museum and Sculpture Garden, Smithsonian Institution, Washington, D.C.: Gift of Joseph H. Hirshhorn, 1966. © Estate David Smith / Licensed by VAGA, New York, NY*

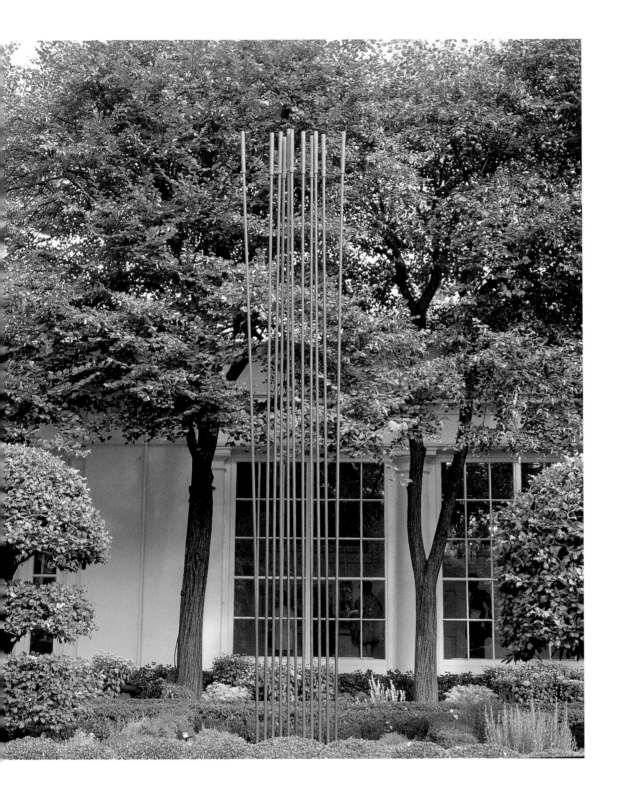

Harry Bertoia (1915–1978).
Tonal Sculpture. *1977.*
Beryllium copper with
bronze weights, height 17' 8",
base 48⅜" square. National
Gallery of Art, Washington,
D.C.: Gift of Bernard and
Audrey Berman, 1984

Harry Bertoia's *Tonal Sculpture*, like many of his works, consists of upright metal rods, this time made of beryllium copper with bronze weights. The lines are so delicate that photographs from certain positions, particularly those taken straight on, would not show the work to its best advantage; the forms would be lost among the distracting elements in the background. But photographing the sculpture against dark foliage made it possible to see the rhythm of the lines. Like many of Bertoia's works, this one produces musical tones as the rods sway in the wind.

The giant Alexander Calder stabile *Nenuphar* was at the west end of the garden, and I was able to photograph it against the facade of the White House. This was an ingenious composition with typical Calder curving forms, each with a different pattern. An unusual feature of this work was the upright pole in the middle and the group of fins on top pointing in different directions.

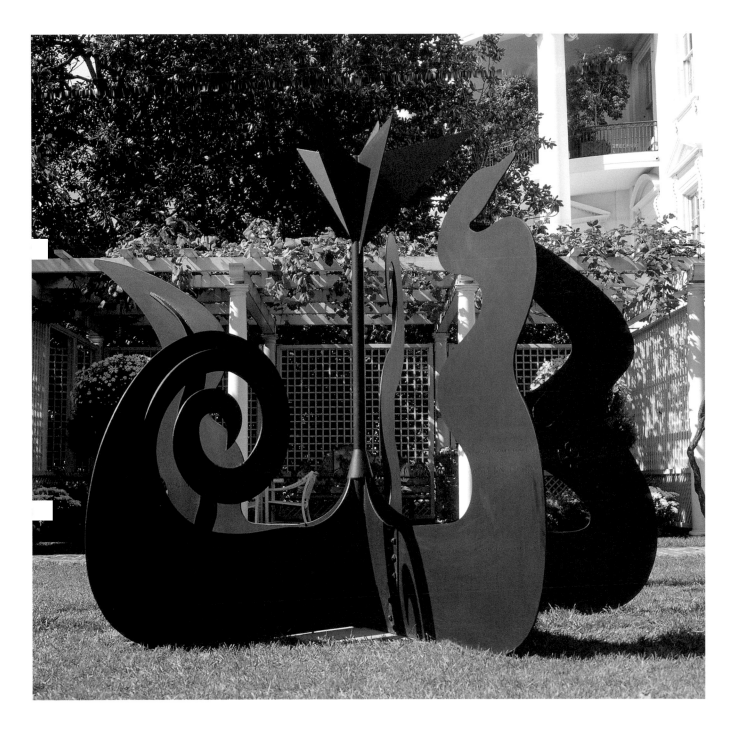

Indoors there was a Roy Lichtenstein

sculpture called *Untitled Head I*, made

of solid brass on a brass-plated steel

base. More abstract than much of

Lichtenstein's work, the sculpture has

an unusual glow and looks as if made

of gold. The facial features, visible

at the edge of the work, complement

the design elements that are its

main feature.

Roy Lichtenstein (1923–1997). Untitled Head I. *1969–70. Solid brass on brass-plated steel base, 25⅝ x 10¼ x ⅜". National Gallery of Art, Washington, D.C.: Gift of Gemini G.E.L., 1981*

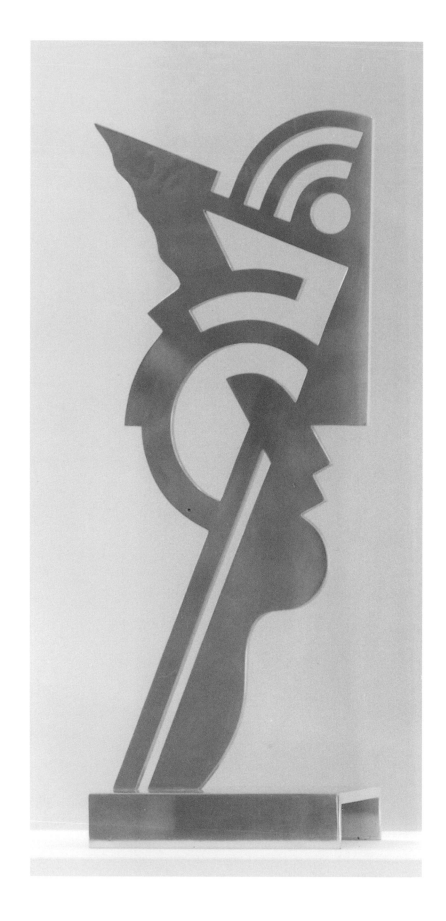

The other sculpture inside was *Five Horses* by Immi Storrs. The heads of three horses point in one direction while the heads of two point in another, giving the composition unity while achieving individual identity for each of the animals. The figures are realistic, yet are arranged in a formal design pattern.

Immi Storrs (born 1945). Five Horses. *1988. Bronze, 12 ½ x 23 ½ x 25". The National Museum of Women in the Arts, Washington, D.C.: Gift of Mr. and Mrs. Joseph P. Carroll*

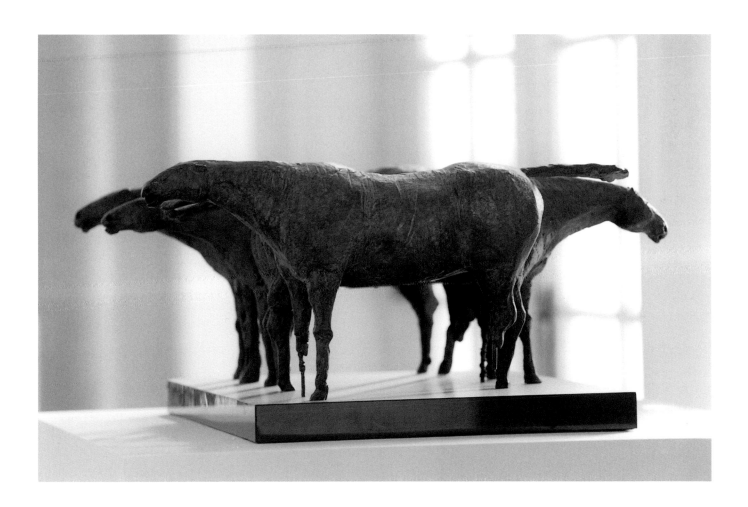

6

The sixth exhibition, which opened in November 1997, marked the first time there had been a large and representative collection of contemporary Native American sculpture in Washington, D.C. Subtitled "Honoring Native America," it was organized by Martin Sullivan, Director, and Curator of Fine Art Margaret Archuleta of The Heard Museum in Phoenix, Arizona.

It was a mostly gray day with a touch of blue sky when I arrived to photograph the sculptures in the exhibition. I began with *Khwee-seng (Woman-man)* by Nora Naranjo-Morse, a semiabstract bronze representation of Native American people. The only decorative elements are the woman's green earrings and necklace. The square bodies have flat fronts and slightly raised areas with suggestive shapes in dark brown. The woman has a design element on top to represent breasts and another below to represent the lower part of her body from the navel downward. On the man, the light jagged line in the middle of the dark area could represent hair, or perhaps the point at which a man and a woman connect to each other.

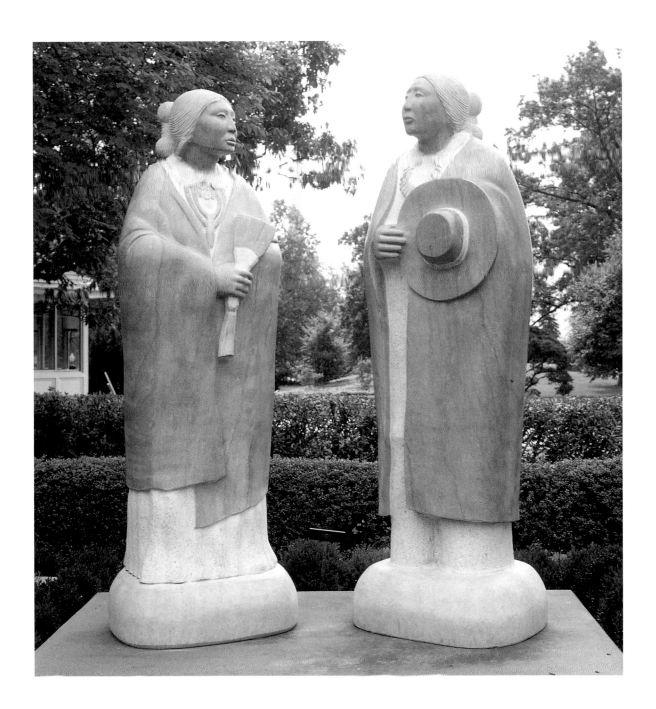

Doug Hyde's *Flag Song*, carved in Tennessee pink marble, is a more traditional representation of man and woman. Here, each is wearing a simple shawl covering a white garment. Standing on rounded stones, the figures could be part of a formal monument. The posture of both is sensitively portrayed and the respect and affection evident in their demeanor reveal an inner dignity.

Allan Houser has been called the patriarch of contemporary Native American sculpture. When President Bush gave him the National Medal of the Arts, he said that Houser had been able to "capture the true meaning of this country's unbroken spirit . . . [and] echo this nation's heritage of proud Apache chiefs and speak for the essential humanity of all Americans." Houser's sculpture, *Earth Song*, done in Alabama marble, is typical of his many works that present traditional Native American themes in a modern idiom.

Allan Houser (1914–1994). Earth Song. 1978. Alabama marble, 48½ x 24 x 24". The Heard Museum, Phoenix, Arizona: Gift of the Gallery Wall, Inc,. in honor of the museum's golden anniversary

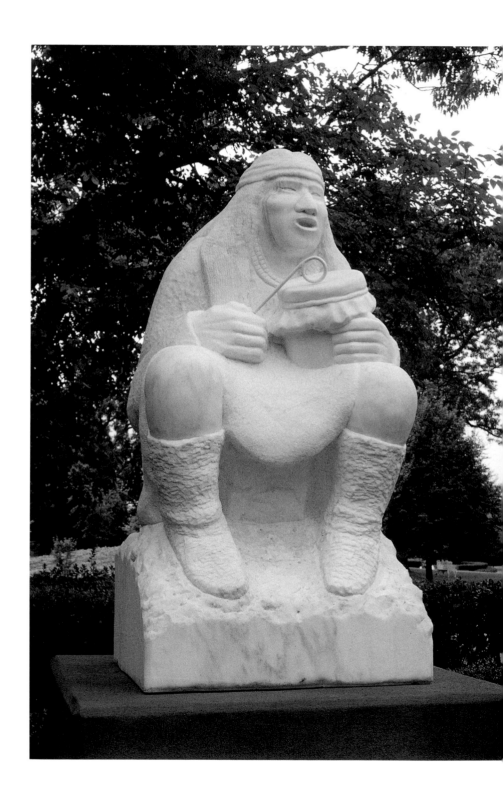

The Cedar Mill Pole by R.E. Bartow is made of carved cedar. The incised marks on the pole create a weaving pattern that imparts a notable elegance. Located on the south side of the White House garden, it rose to a considerable height under the neighboring trees and occupied the space with its monumental vertical form. (The Washington Monument could be seen behind it.)

R.E. Bartow (born 1946). The Cedar Mill Pole. *1997. Carved cedar, height 26'. Washington County, Oregon, and Oregon College of Arts, Portland: Funding from the Regional Art and Culture Council, Portland, Oregon, and private contributors*

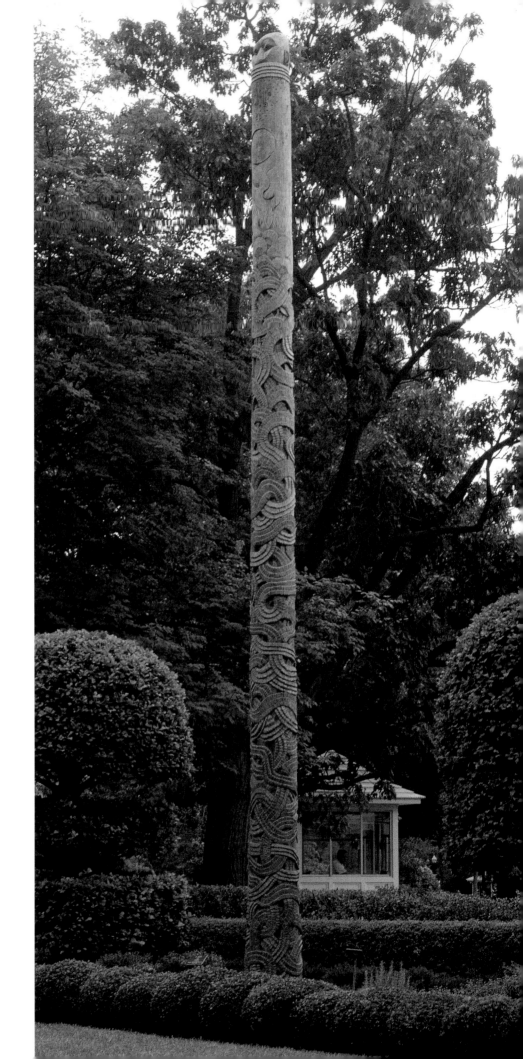

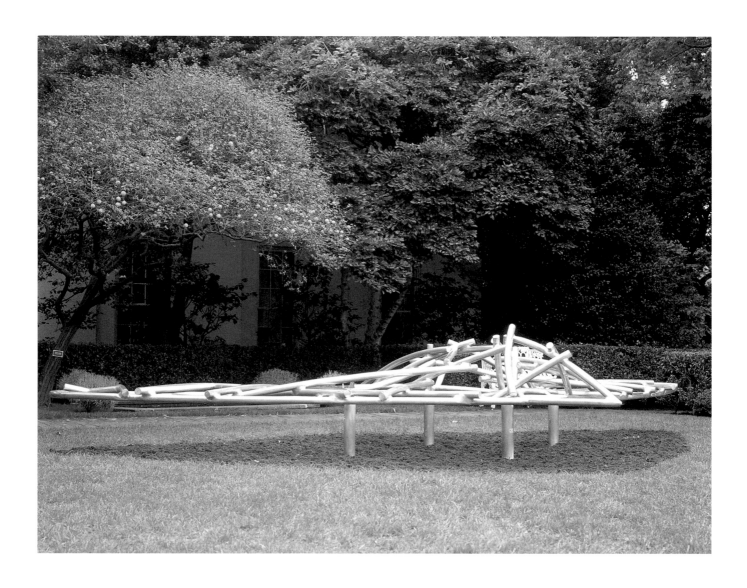

At the east end of the garden was a low, sprawling aluminum sculpture, *Bird Effigy*, by Truman Lowe. The goal of the work was, in the artist's words, to "capture that image formed from that obscure place where past, present, and future are one. To know the universe for a moment. . . ." The aluminum sections were connected into a complex pattern of interweaving forms and suspended on four short legs. I had to hold my camera almost at ground level in order to produce images of this striking form.

On the other side of the interior space was *Lady of Spring* by Willard Stone. Stone's wood sculptures are both modern and decorative, and this is one of the finest examples of his work. He has combined realism with abstraction in this organic female form. Inspired by his concept of Mother Earth, it shows a beautiful woman blossoming like a flower out of a seed. The lines are clean, flowing, and sensuous, the surface smooth and highly glossed.

Willard Stone (1915–1985). Lady of Spring. *Date unknown. Walnut, 27½ x 5 x 5½". Gilcrease Museum, Tulsa, Oklahoma*

Doug Coffin (born 1946).
Earth Messenger Totem.
c. 1997. Painted steel, 28 x 6 x 2'.
Wheelwright Museum of the
American Indian, Santa Fe,
New Mexico: Gift of Meg Heydt

Rising high above the foliage was *Earth Messenger Totem,* by Doug Coffin. This

28-foot-high painted-steel sculpture is a mix of contemporary design and spiritual

mythology. The bright colors and abstract forms end in a red triangle pointing

upward against a blue sky, giving the work a dynamic vitality.

Sea Weed People by John Hoover is a graceful work in which the forms grow upward and outward from what seems to be a watery basin. The bronze is painted blue-green to give the forms a vegetative appearance, and each of the figures is outlined in bright colors. The simple faces make the curving shoots seem human.

John Hoover (born 1919).
Sea Weed People. c. 1994.
Bronze, height 9', diameter 4'.
The Heard Museum,
Phoenix, Arizona

The aluminum cut-out figures called *Guardians and Sentinels* by Susie Bevins Ericsen/Qimmiqsak looked like ghosts hovering in front of the windows of the White House corridor. Each of the three shapes is different. Holes in the aluminum sheets indicate facial features and may represent powers coming from the hands or chest. The smallest figure has streams of hair or light coming out of its head, perhaps also indicating its spiritual qualities.

Susie Bevins Ericsen/ Qimmiqsak (born 1941). Guardians and Sentinels. *1994. Aluminum, 9′ x 12′ x 1″. Municipality of Anchorage, Alaska*

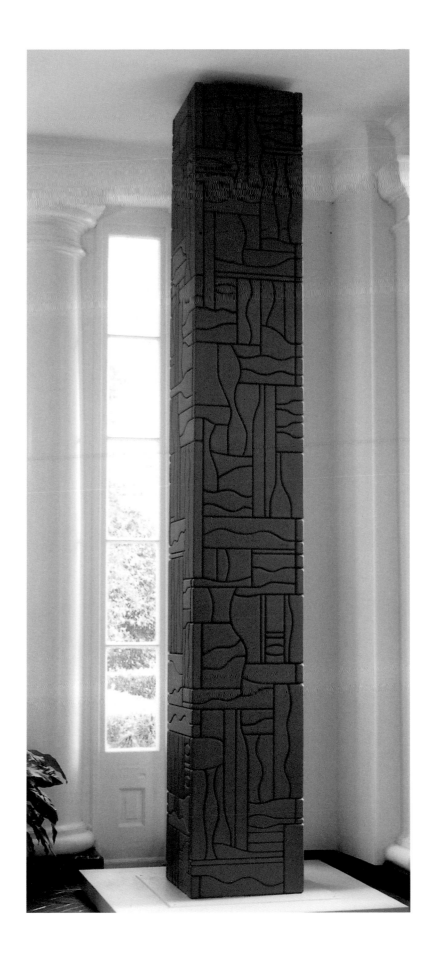

Inside, standing in a corner, was George Morrison's *Red Totem*. Carved in cedar and stained a very dark, rich earth red, this square totem reached almost to the ceiling. It was inspired by the carved cedar totem poles of the Northwest, but without any images of human heads or animals. Instead, the sculptor created small abstract shapes resembling mosaics.

George Morrison (born 1919). Red Totem. 1980. Stained cedar, 12' x 20" x 20". The Heard Museum, Phoenix, Arizona: Acquisition made possible by grants from Koll Company and Beta West Company

Nearby, in front of the windows, was *The Emergence of the Clowns* by Roxanne Swentzell. A work in mixed media clay, it may derive from Pueblo myths, as have other works by this artist. The figures represent the ascent of the Pueblo people into this world. They are *koshares*, or "sacred clowns." Swentzell has captured the feelings of wonderment, awe, knowledge, and joy.

Roxanne Swentzell (born 1963). The Emergence of the Clowns. 1988. Mixed media clay, height of tallest figure 22". The Heard Museum, Phoenix, Arizona: Purchased with funds from the Koll Company

The son of well-known artist Allan Houser, Bob Haozous developed his own style related to his Apache background and his studies in Zen Buddhism. Haozous's *Woman in Love* lies on her side as if floating in air. With her eyes closed and her hands held flat against her body, she seems to be a study in faith and humility. Haozous saw some of his sculptures as expressions of gratitude to the Great Spirit for the fertility of the land and the beauty of crystal clear waters. This one seems to be an expression of reverence for the courage and determination of the artist's ancestors to overcome their burdens and sorrows and welcome the advent of a new season.

Bob Haozous (born 1943).
Woman in Love. *1983.*
Stainless steel, 18 x 53 x 8".
The Heard Museum,
Phoenix, Arizona

7

The seventh exhibition, which opened in November of 1998, was subtitled *Inspired by Rodin* and showed works by American artists who were indebted to Rodin's monumental achievements. Organized by Arnold L. Lehman, Director of the Brooklyn Museum of Art in New York, it was a tribute to Iris and B. Gerald Cantor, whose foundation had sponsored seven of the exhibitions at the White House. The Cantors had what was considered to be the largest private collection of Rodin sculptures in the world, and had made substantial gifts from the collection to the Brooklyn Museum and many other institutions in the United States. Owing to the special nature of the theme, three works by Rodin, the only non-American sculptures included in any of the eight exhibitions, were among those chosen.

It was an overcast day when I arrived in Washington to photograph the works in the exhibition. I began with William Zorach's casota limestone *Wisdom of Solomon*. As with all of Zorach's sculptures, the figures are simple, direct, and beautifully carved. In conception it is reminiscent of Henry Moore's *Family Group*, which had been sculpted a few years earlier, although here two mothers show their love for the child rather than a mother and father. Both mothers seem confident of their rights, and the child has a bewildered look on his face, perhaps anticipating the decision by King Solomon that will determine his fate.

William Zorach (1887–1966). Wisdom of Solomon. *1966. Casota limestone, 38½ x 30½ x 26". Brooklyn Museum of Art, New York: Bequest of Lester Avnet*

Girl Standing in Nature was a strong, naturalistic bronze sculpture by George Segal. Here the nude figure stood directly on the ground, with no pedestal between her feet and the earth. Somehow it did not seem at all inappropriate for this nude woman to be standing in the garden outside the White House, since she was not at all self-conscious as she looked around her. Presumably cast from life like Segal's other sculptures, the figure had a striking presence.

George Segal (born 1924). Girl Standing in Nature. *1976. Bronze, 65½ x 21½ x 11½". Presented to the town of Greenwich, Connecticut, by the Greenwich Arts Council in commemoration of the Bicentennial Year, 1776–1976. © George Segal / Licensed by VAGA, New York, NY*

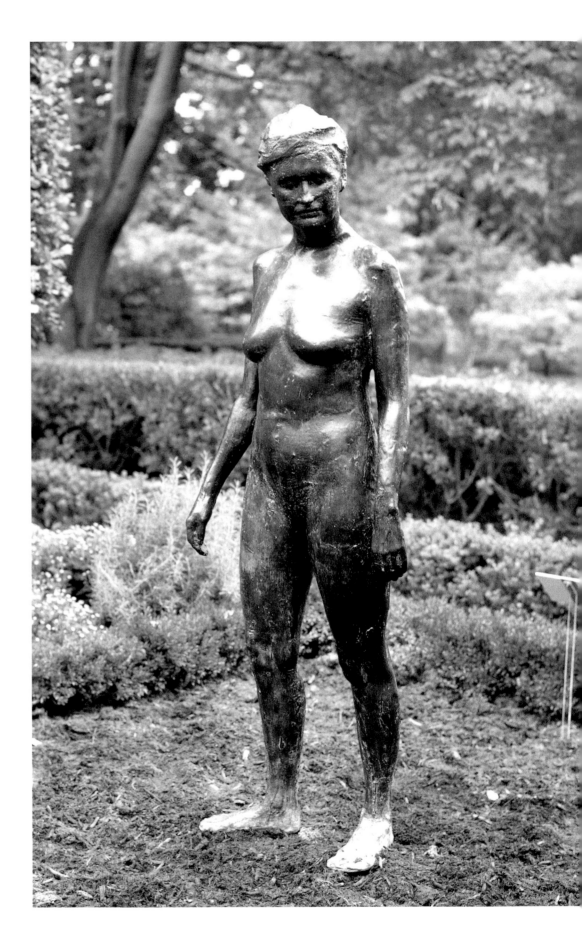

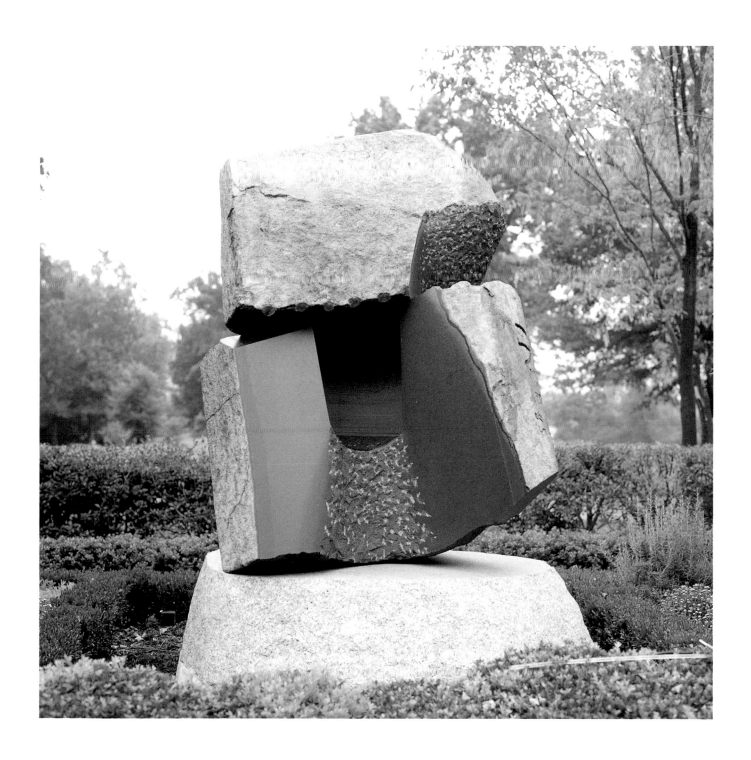

By contrast, the femininity of Isamu Noguchi's *Woman* was less apparent, though it was a marvelous juxtaposition of forms in basalt, with a granite base. The sculpture seemed to have a life of its own in both shape and texture, and the elements were perfectly composed. One felt that Noguchi had somehow revealed a living being contained within the stone.

Isamu Noguchi (1904–1988). Woman. 1983–85. Basalt with granite base, 66 x 49 x 44″. The Isamu Noguchi Foundation, Inc., Long Island City, New York

In the southeast corner of the garden was Andrew O'Connor's limestone carving *Tristram and Iseult*. It was not hard to see how this composition might have been inspired by Rodin. The two sculptors were contemporaries, and the loving pose of the figures bears some relationship to Rodin's many images of lovers. In this work the sculptor added abstract elements that give it a special distinction.

Andrew O'Connor, Jr. (1874–1941). Tristram and Iseult. *1928. Limestone, 76 3/8 x 33 7/8 x 34 5/8". Brooklyn Museum of Art, New York: Dick S. Ramsay Fund*

Standing Figure with

Blue Shoulder is one of
Stephen De Staebler's
striking sculptures in
which naturalistic
representations of the
human figure are
combined with organic
forms. The work as a
whole is beautifully
conceived, with various
surprises, such as the
blue patina on the
shoulder. These strong
accents impart a
distinctive quality to
the sculpture.

*Stephen De Staebler (born
1933).* Standing Figure with
Blue Shoulder. *1983. Bronze,
ed. 3/3, 76½ x 17 x 17¼".
Neuberger Museum of Art,
Purchase College, State
University of New York: Gift
of Mr. and Mrs. David Guss
on the occasion of Roy R.
Neuberger's 85th birthday, 1987*

Auguste Rodin's *The Three Shades* was one of the masterpieces that helped make this exhibition a landmark. It is one of Rodin's most remarkable works—and almost impossible to photograph adequately because of the shadows created in almost any light. The overall design of the three figures standing in different but harmonious postures was brilliantly composed. The well-formed limbs, taut muscles, soulful faces, and the spaces created between the forms all produced a veritable encyclopedia of sculptural elements.

Auguste Rodin (French, 1840–1917). The Three Shades. *1881–86, enlarged 1898. Coubertin Foundry, cast II/IV. Bronze, 75½ x 75½ x 42". Iris and B. Gerald Cantor Foundation*

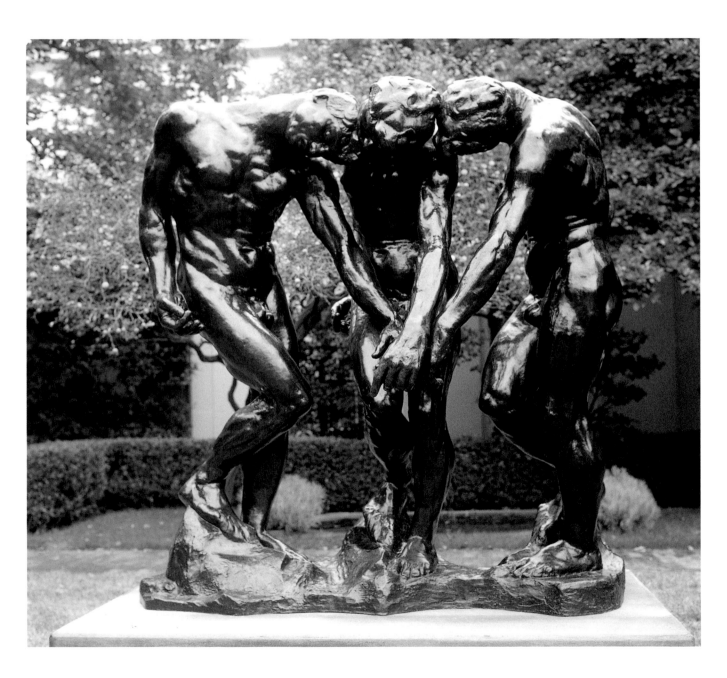

Malvina Hoffman was one of the leading American sculptors in the first half of the twentieth century, and Ivan Mestrovic, a Croatian, was a leading European contemporary of hers. (He was born in 1883 and she in 1885.) It is not surprising, then, that Hoffman would create a portrait to honor a man who was described by Rodin as "the greatest phenomenon among sculptors." Her work shows a dynamic figure in his workshop clothes studying a small maquette held in one hand. The folds of his loose smock and baggy pants seem filled with dynamic energy, as does the tense brow of the bearded and balding sculptor.

Malvina Hoffman (1887–1966). Ivan Mestrovic. c. 1925. Bronze, 86⅝ x 42⅛ x 31½". Brooklyn Museum of Art, New York: Gift of Felix Warburg and Mrs. Edward C. Blum

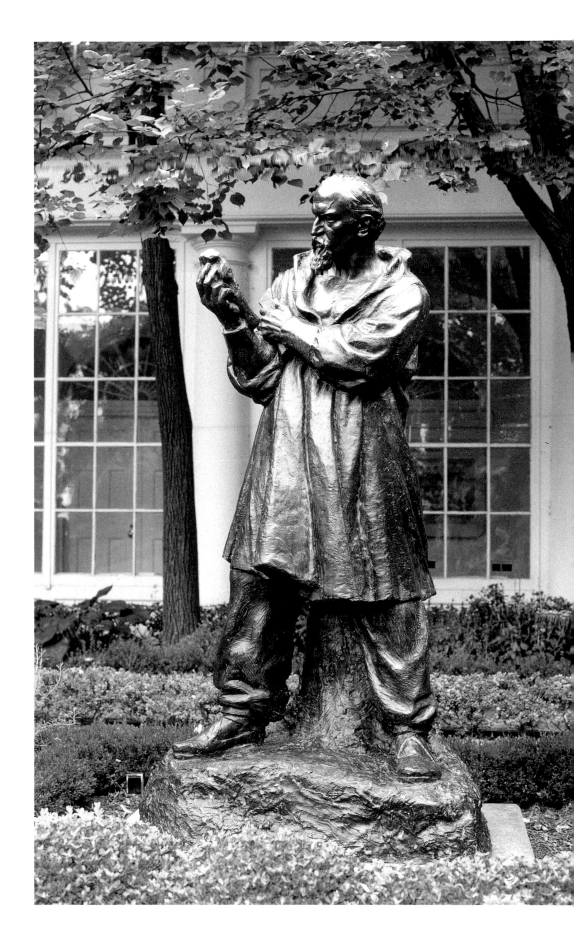

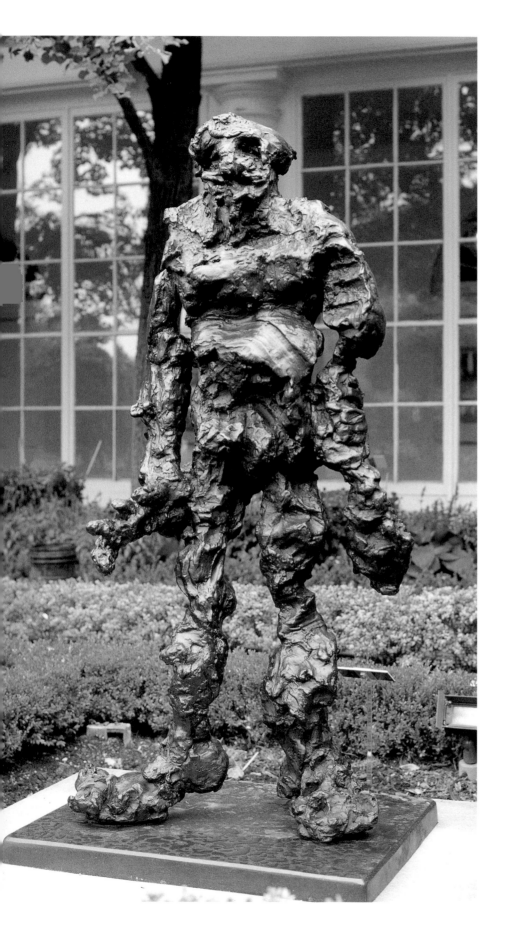

Looking at Willem de Kooning's *Clamdigger*, one can almost feel vigorous brushstrokes in the bronze. The figure's stance, the position of its hands and feet, and the vacant expression on its face are almost incidental to the strong bulges, indentations, and gashes found throughout the surface, which give it its character.

Willem de Kooning (1904–1997). Clamdigger. 1972. Bronze, ed. 2/7, 57½ x 24½ x 21". Whitney Museum of American Art, New York: Gift of Mrs. H. Gates Lloyd. © 2000 Willem de Kooning Revocable Trust / Artists Rights Society (ARS), New York

Bryan Hunt's bronze *Big Twist* is similar to his *Shift Falls* in the first exhibition.

In this case, the sculpture was not inspired by falling water, but by the human

figure. The elongated form shows an outsize leg, arm, or torso reaching into space.

Bryan Hunt (born 1947).
Big Twist. 1978. Bronze,
12' x 18" x 18", including
limestone base designed by
the artist. © 2000 Bryan
Hunt / Artists Rights Society
(ARS), New York. The
Museum of Modern Art,
New York. Gift of Carl D.
Lobell. Photograph by David
Finn, © 2000 The Museum
of Modern Art, New York

At the end of the garden, with its back to the White House, sat Rodin's *The Thinker,* mounted on a high pedestal. There have been so many casts of this sculpture, and photographs of it have been so widely reproduced, that it is hard to see with a fresh eye. On this site, however, its monumentality was overwhelming. The brooding face, the expressive posture, and the sheer power of the muscular forms all combined to reveal this as one of Rodin's most memorable works.

Auguste Rodin (French, 1840–1917). The Thinker. 1880, enlarged 1903–4. Bronze, 79 x 51¼ x 55¼". Georges Rudier Foundry, cast 10/12. Iris and B. Gerald Cantor Foundation. Promised gift to the Iris and B. Gerald Cantor Center for Visual Arts at Stanford University

Inside was Rodin's marble carving *Memorial Relief (Hand of a Child)*. Photographing this piece from the top was quite challenging, though it was the only way to show the delicate form of the hand against the flat surface of the stone, with the carefully composed chisel marks at the edges. It was very moving to realize that this delicate sculpture was created to memorialize the death of a child.

Auguste Rodin (French, 1840–1917). Memorial Relief (Hand of a Child). *c. 1905. Marble, 5⅞ x 16 x 12⅞". National Gallery of Art, Washington, D.C.: Gift of Elizabeth Merrill Furness*

Nearby was another marble carving, *Décontractée*, by Louise Bourgeois, this time with two hands in relief. It was an intriguing idea to place the Rodin and Bourgeois sculptures together, since at first they seem very much alike— on close examination, there are marked differences. As its name suggests, the Bourgeois hands are broken below the wrists, as if they are study models. They face upward rather than down, and the palms of the hands and position of the fingers are so realistic that they look as if they had been cast from life, which of course they were not, since they were carved in marble. Another significant difference is the nature of the chisel marks on the surface of the marble block, which in the Bourgeois piece seem almost like a detached background rather than a composed form.

Louise Bourgeois (born 1911). Décontractée. 1990. Pink marble and steel base, 28½ x 36 x 23". Brooklyn Museum of Art, New York: Purchased with funds given by Mary Smith Dorward Fund, the Contemporary Art Council, the David H. Cogan Foundation, Inc., Harry Kahn, Mrs. Carl Selden; and gift of Edward A. Bragaline by exchange, 1994. © Louise Bourgeois / Licensed by VAGA, New York, NY

8

The eighth and final exhibition opened in October 1999. Subtitled "The View from Denver" and featuring works from Denver institutions, it was organized by Lewis I. Sharp, Director of The Denver Art Museum. Diane Perry Vanderlip, Cynthia Madden Leitner, and Ginny Williams curated.

This time I had the benefit of a bright, sunny day, with not a cloud in the sky. I began by photographing Robert Mangold's *Windsong III*, and was delighted to capture the many different colors of the painted-steel forms brilliantly lit against the blue sky. I used a fast setting on my camera—shooting at 1/250th of a second—which enabled me to fix still images of the constantly moving parts.

Robert Mangold (born 1937). Windsong III. 1989. Steel, approximately 12' high x 8' diameter. The Museum of Outdoor Arts, Englewood, Colorado. © 2000 Robert Mangold / Artist Rights Society (ARS), New York

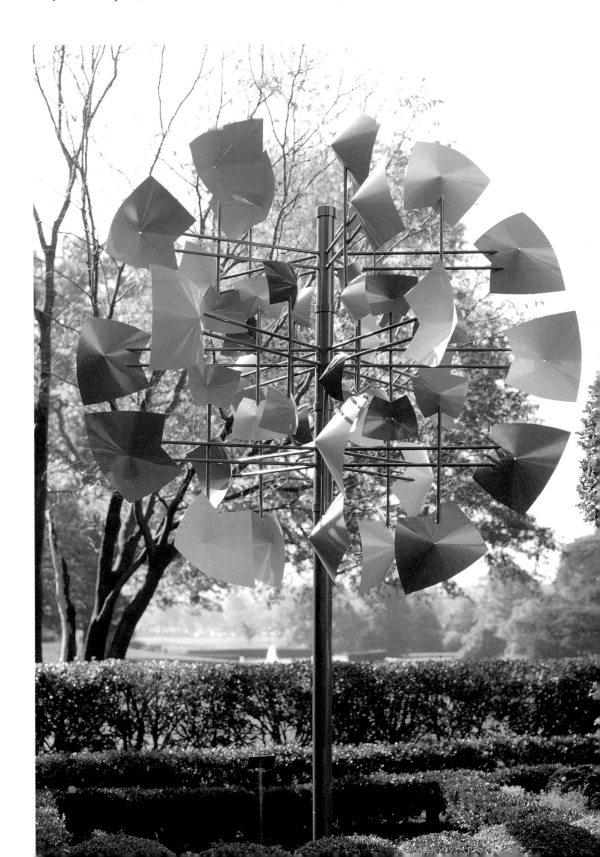

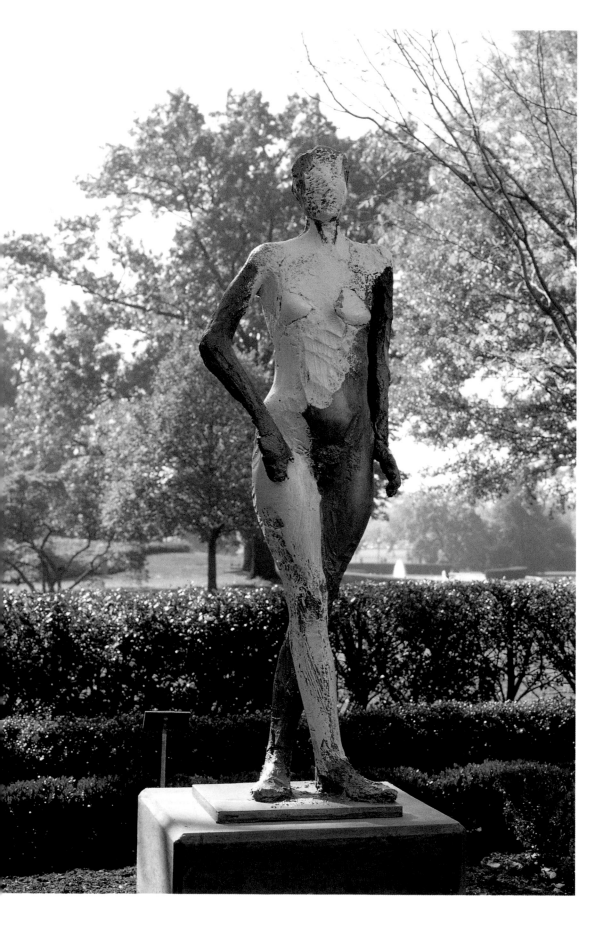

Next was *Untitled*, a female figure by Manuel Neri. The first exhibition included a Neri sculpture in white marble; this one was in bronze with oil-based enamel. A classical figure in a contemporary vocabulary, it showed a woman standing with her legs crossed, seemingly watchful of the scenery around her.

Manuel Neri (born 1930). Untitled. 1991 (cast). Bronze with oil-base enamel, ed. 1/4, 65 x 18 x 15¼". Denver Art Museum: Funds from 1985 and 1986 Alliance for Contemporary Art Auctions by exchange, the NBT Foundation, Jennifer Doran and Jim Robischon, and Barbara Burrell, 1996. 33

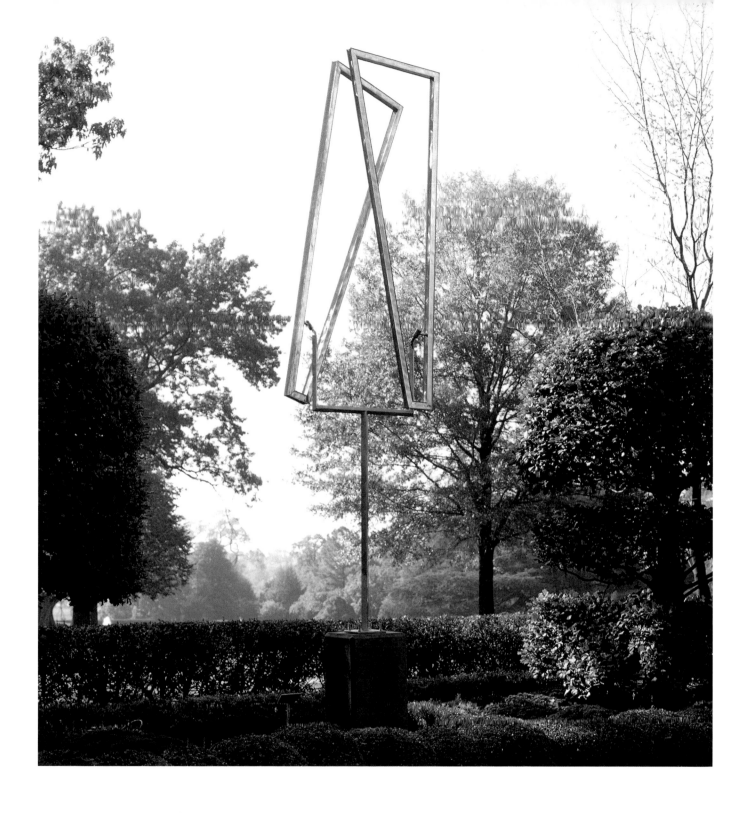

It was delightful to see George Rickey's *Two Open Trapezoids Excentric V* moving against the sky. Once again, a fast speed in my camera setting enabled me to fix the image of the piece in different positions. The metal forms glistened in the sun and made fascinating compositions as they swung back and forth on their armature.

George Rickey (born 1907). Two Open Trapezoids Excentric V. *1978. Polished stainless steel, ed. 2/8, 12' 10" x 40" to 13' 4". The Museum of Outdoor Arts, Englewood, Colorado. © George Rickey / Licensed by VAGA, New York, NY*

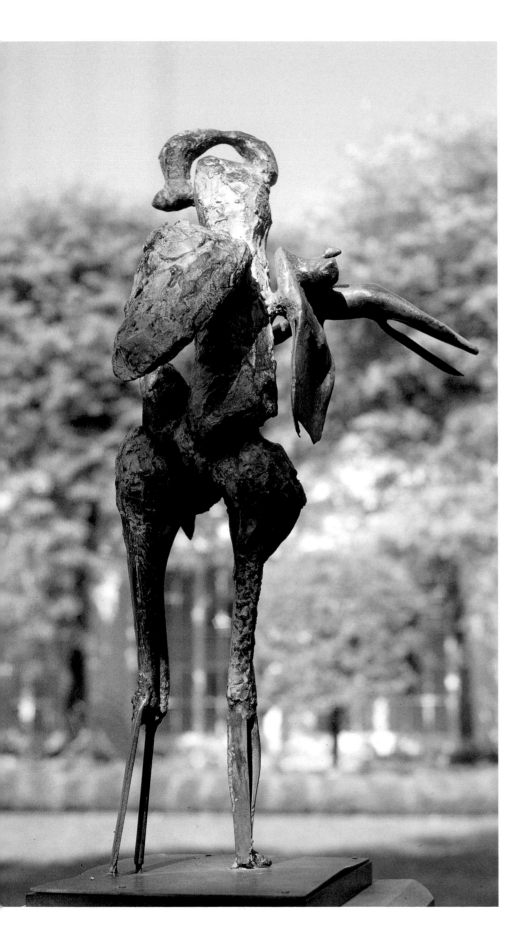

Made of bronze, steel, and copper, an early expressive work by Richard Hunt, titled *Icarus,* has the appearance of the mythical man-bird hoping to fly in the air. It seems partially disfigured, as if it had tried to take off and had fallen to the ground, its body and wings mangled and broken.

Richard Hunt (born 1935). Icarus. 1957–58. Bronze, steel, and copper, 32 ½ x 17 x 11 ¼". Denver Art Museum: Gift of Mr. and Mrs. Burton J. Wade, 1986. 181

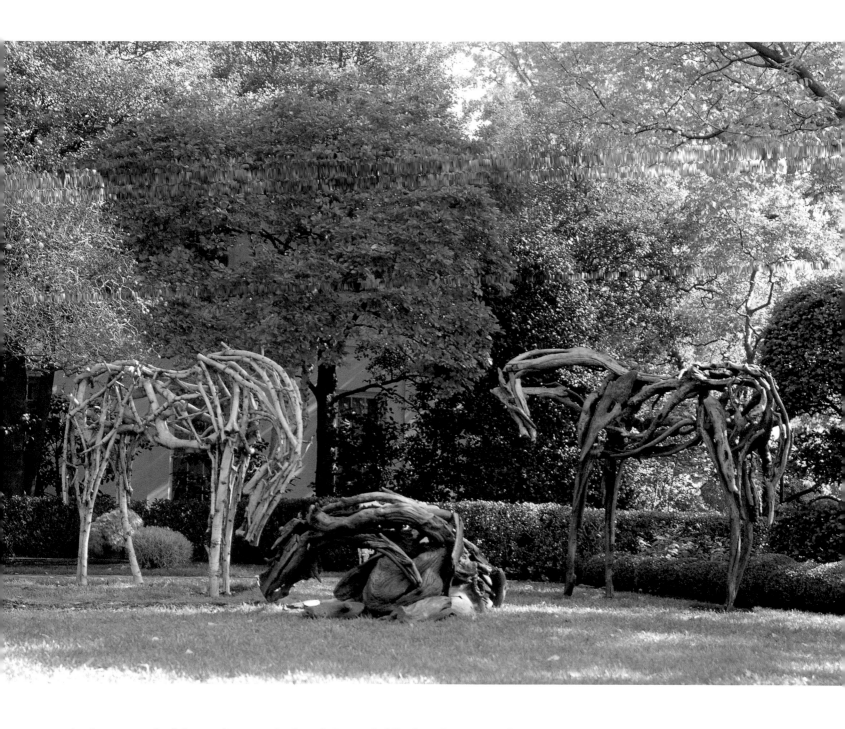

At the east end of the garden were Deborah Butterfield's three horses, *Willy, Argus, and Lucky,* in painted and patinated bronze. The animal forms made of casts from twigs and branches showed the horses in different positions. Because one of the horses is recumbent, I had to bend over to photograph it. All three horses are seen in realistic, graceful stances, with the spaces within the figures as intriguing as the elements that shaped them.

Deborah Butterfield (born 1949).
Willy, Argus, and Lucky. *1996–97.*
Painted and patinated bronze,
85 x 92 x 54¾"; 84¾ x 100 x 37";
33½ x 93¾ x 59½". Denver Art
Museum: Funds from the Enid
and Crosby Kemper Foundation,
UMB Bank Trustees, 1996. 198. 1–3

113

Preston Duwyenie (born 1951).
Cloud Stone. *1987. Alabaster
and copper, 46 x 22½ x 10½".
Denver Art Museum: Gift
of Peter and Nanci Jacobs, 1998.
12AB*

Cloud Stone is an abstract sculpture by Preston Duwyenie, a Hopi Indian from

Northern Arizona. According to the artist, this alabaster and copper form is

a contemporary expression of the creation mythology of his tribe—that Mother

Earth and Father Sky had come together to give birth to life on earth. The stone

was skillfully carved to create a dramatic receptacle for the metal rod that reaches

into its inner being.

Isaac Witkin's *Chaka* lay close to the ground. A painted steel sculpture, its intriguing composition consists of a disc, intersecting circular bands, and rods both in the upper part of the work and at the base. Witkin studied with Henry Moore and Anthony Caro, and in this piece one can see a relationship to some of Caro's constructions.

Each one of Louise Bourgeois's pieces is a product of her distinctive vision. *Black Flames* is a vertical bronze piece depicting flames rising from a sort of candle, taper, or even a chimney, with a small hole toward the top. Each element seems to have some hidden meaning.

Louise Bourgeois (born 1911). Black Flames. *1947–49. Bronze, 69½ x 9½ x 12". The Ginny Williams Family Foundation. © Louise Bourgeois / Licensed by VAGA, New York, NY*

There was no music sounding when I photographed Harry Bertoia's sculpture *#26*, because there was no wind to move the vertical brass rods against each other. Nevertheless, the rods formed a harmonious unity against the trees and building in the background. The simple forms created a striking pattern that was easily recognizable as one of Bertoia's outstanding works.

Harry Bertoia (1915–1978). #26.
c. 1975. Brass, 70 1/4 x 18 x 6".
Phoenix Art Museum, ARCO
gift, 111.25

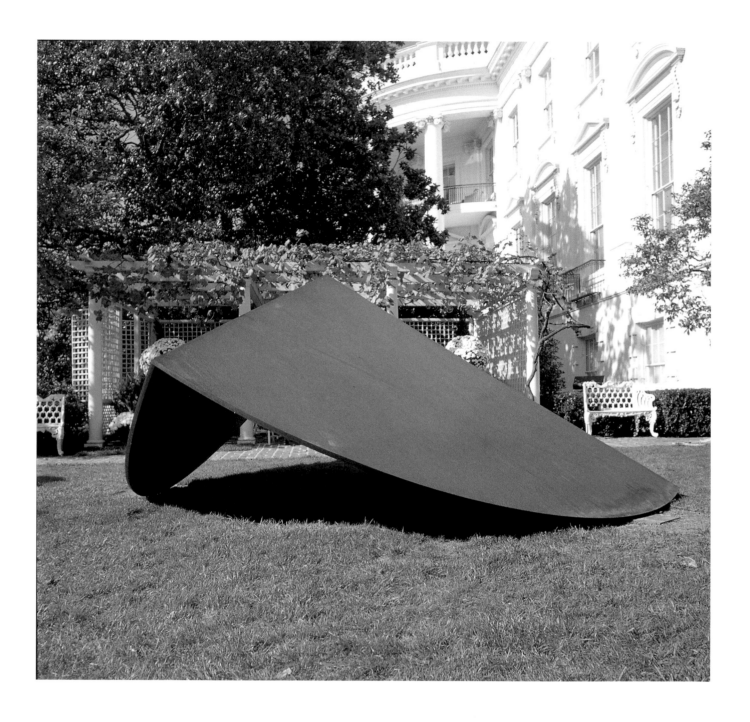

In the center of the lawn, with the White House in the background, was Ellsworth

Kelly's weathered-steel work *Untitled (EK 680)*. It is always amazing to see how

much one can discover in Kelly's geometric forms. In this case, the sun and the

shadows it cast helped me find a variety of compositions. The angled top, slanting

upward on one end, offered many striking images for my camera eye. Various side

views showed intriguing shapes of the form against the background.

Inside was *Remembrance*
by Isamu Noguchi,
an early work originally
made in mahogany
It stands on three legs,
the curving pieces above
leaning, stretching,
and bending—creating
a pattern that has a
rhythm of its own.

Opposite was Claes Oldenburg's

Clothespin—4 Foot Version. As always,

it was eye-opening to see one of

Oldenburg's oversize renditions of an

object we would never look at in

aesthetic terms. Here, the curved lines

of each side, the metal ring that holds

them together, and the openings

made for hanging on a line—all had

a design quality that was startling,

playful, and beautiful.

Claes Oldenburg (born 1929). Clothespin—4 Foot Version. 1974. Artist's proof. Bronze and stainless steel, 48 x 17½ x 20½". Denver Art Museum: Funds from Alliance for Contemporary Art; Brownstein, Hyatt, Farber & Madden; Kenneth M. Good, 1981

Thus ended my adventure of photographing sculpture at the White House. It had given me an opportunity to focus my camera on a wide variety of works by twentieth-century American sculptors, and I came away feeling that it had been a rich period of creative innovation and achievement.

While the series of exhibitions was not intended to be a cross section of the period's leading sculptors, the range was wide. The works were chosen by the curators of eight leading museums around the country, each selecting works for an individual exhibition. The result was eight groupings of outstanding works that were ideally suited for exhibition in the lovely Jacqueline Kennedy Garden. There is no doubt that they gave visitors to the White House during the Clinton administration an appreciation for the quality and diversity of American art.

LIST OF LENDING INSTITUTIONS

Akron Art Museum, Ohio

Albright-Knox Art Gallery, Buffalo, New York

The Arkansas Arts Center, Little Rock

The Art Institute of Chicago, Illinois

Birmingham Museum of Art, Alabama

The Brooklyn Museum of Art, New York

Columbus Museum of Art, Ohio

Dallas Museum of Art, Texas

DeCordova Museum and Sculpture Park,
 Lincoln, Massachusetts

The Denver Art Museum, Colorado

The Georgia O'Keeffe Foundation, Abiquiu,
 New Mexico

Gilcrease Museum, Tulsa, Oklahoma

The Ginny Williams Family Foundation

The Heard Museum, Phoenix, Arizona

High Museum of Art, Atlanta, Georgia

Hirshhorn Museum and Sculpture Garden,
 Smithsonian Institution, Washington, D.C.

Hunter Museum of American Art,
 Chattanooga, Tennessee

Iris and B. Gerald Cantor Foundation

Isamu Noguchi Foundation, Inc.,
 Long Island City, New York

The J.B. Speed Art Museum, Louisville, Kentucky

Laumeier Sculpture Park, St. Louis, Missouri

The Los Angeles County Museum of Art, California

The Metropolitan Museum of Art, New York

Michael C. Carlos Museum, Emory University,
 Atlanta, Georgia

Milwaukee Art Museum, Wisconsin

Minnesota Museum of American Art, St. Paul

Modern Art Museum of Fort Worth, Texas

Municipality of Anchorage, Alaska

The Museum of Contemporary Art, Chicago, Illinois

The Museum of Contemporary Art, Los Angeles,
 California

The Museum of Fine Arts, Houston

The Museum of Modern Art, New York

The Museum of Outdoor Arts, Denver, Colorado

The National Gallery of Art, Washington, D.C.

National Museum of American Art,
 Smithsonian Institution, Washington, D.C.

The National Museum of Women in the Arts,
 Washington, D.C.

Neuberger Museum of Art, Purchase College,
 State University of New York

The New Museum of Contemporary Art, New York

New Orleans Museum of Art, Louisiana

Norton Gallery of Art, West Palm Beach, Florida

The Old Jail Art Center, Albany, Texas

Orlando Museum of Art, Florida

The Sheldon Memorial Art Gallery and Sculpture
 Garden, University of Nebraska–Lincoln

Solomon R. Guggenheim Museum, New York

The Studio Museum in Harlem, New York

Town of Greenwich, Connecticut

Walker Art Center, Minneapolis, Minnesota

Washington University Gallery of Art,
 St. Louis, Missouri

Washington County Oregon College of Arts, Portland

Wheelwright Museum of the American Indian,
 Santa Fe, New Mexico

Whitney Museum of American Art, New York

BIOGRAPHICAL INDEX OF ARTISTS

Biographical information on the artists was provided by the curatorial staffs of the lending institutions.

ARCHIPENKO, ALEXANDER (1887–1964)

Alexander Archipenko was born in the Ukraine. After attending art school in Kiev, he studied in Moscow and then briefly at the Ecole des Beaux-Arts in Paris. Through his friend Fernand Léger, Archipenko joined the group of nascent Cubist artists and exhibited with them from 1910 to 1914. One of the movement's most daring sculptors, he modeled and constructed radically innovative works, using unprecedented materials such as cement, paper, and various metals. He opened up solid forms with bold concavities, convexities, and perforations (his art was briefly known as the "sculpture of holes"), and he painted many works in variegated colors, calling them "sculpto-paintings." By 1920, his fame was international, with exhibitions at the Venice Biennale and at Kunsthaus Zürich. After living in Nice during World War I, he returned to Paris and then moved to Berlin, where he operated his own art school from 1921 to 1923.

Archipenko emigrated to the United States in 1923, and opened an art school in Woodstock, New York. From the 1930s to the 1950s he taught at colleges around the country and made reprises of his earlier sculptures. His last years were busy with exhibitions at museums in São Paolo and Dallas (1952), and in Germany (1955–56). Posthumous retrospectives have been presented in many cities, including Washington, D.C., in 1968 and 1986.
The Gondolier is shown on page 78.

BARTOW, R.E. (BORN 1946)

R.E. Bartow, a Yurok, is one of the outstanding Native American artists of the twentieth century, well known for his paintings, works on paper, and carved contemporary masks. Bartow has exhibited extensively in his home state of Oregon, and nationally and internationally as well. He has worked with international indigenous artists, attending artists' gatherings in Japan and New Zealand. In New Zealand, Bartow developed a friendship with Maori artist John Bevan Ford and learned about the Maori carving tradition. The two artists exchanged traditional tools and ideas. Some of Bartow's work shows the results of that friendship and the sharing of traditions. *The Cedar Mill Pole* is shown on page 87.

BERTOIA, HARRY (1915–1978)

Harry Bertoia was born in Italy and moved to the United States in 1930. He studied at the Detroit Society of Arts and Crafts and the Cranbrook Academy of Art in Bloomfield Hills, Michigan, where he also taught (1937–41). His work with Charles Eames in 1943 and Knoll Associates in New York in 1951 gained him recognition as an interior designer, furniture designer, and graphic artist in addition to his reputation as a sculptor. Bertoia received the Fine Arts Medal in 1955 and 1963, the Craftsmanship Medal in 1956, and the Gold Medal of the American Institute of Architects in 1973.
Tonal Sculpture is shown on page 80.
#26 is shown on page 117.

BOOKER, CHAKAIA (BORN 1953)

Born and reared in Newark, New Jersey, Chakaia
Booker received a B.A. degree from Rutgers University
and an M.F.A. from The City College of New York.
She has received various awards and fellowships, and
was artist-in-residence at The Studio Museum in
Harlem from 1995 to 1996. Booker's sculptures are made
from used tires and other found objects. For her, these
objects are a symbolic medium for the expression
of her ideas; they express the versatility of the African
Diaspora, and, in color and pattern, are reminiscent of
motifs found in African fabrics and artwork.
Repugnant Rapunzel (Let Down Your Hair) is shown
on page 66.

BOURGEOIS, LOUISE (BORN 1911)

In her native France, Louise Bourgeois's parents were
tapestry restorers and dealers. In her youth, while
assisting in the restoration process, she learned to draw.
She studied mathematics at the Sorbonne in Paris in
the early 1930s before focusing on art, first at the very
traditional Ecole des Beaux-Arts and then at less
conservative academies. Bourgeois also took art history
courses at the Ecole du Louvre from 1936 to 1938,
where, among other subjects, she studied the work of
Auguste Rodin. Bourgeois came to the United States in
1938 after marrying the art historian Robert Goldwater,
whom she met at the Ecole du Louvre, where he
undertook research for his groundbreaking work on
"primitivism." Initially a painter, Bourgeois started
making sculptures in the mid 1940s. Her work of this
period is indebted to European Surrealism, although
her first exposure to that work was in New York. In
the early 1960s, she began experimenting with materials
and provocative content in her work. From the outset,
in her installations and sculpture, she found inspir-
ation in the human body and her own personal,
unique interpretation of memory.
Observer is shown on page 27.
Décontractée is shown on page 108.
Black Flames is shown on page 116.

BURTON, SCOTT (1939–1989)

Scott Burton was born in Greensboro, Alabama. He
was an innovator whose work challenged the distinc-
tions between fine art and applied arts, sculpture,
and furniture design. A writer and critic for such
publications as *ArtNews* and *Art in America,* Burton
began to explore Performance Art in the 1970s; his
performances were characterized by stagelike tableaux
of found pieces of furniture. He first exhibited furni-
ture from his performance pieces in 1975, independent
of actors, and began to fabricate his own designs.

Burton's aesthetic was shaped by the primary
forms and intellectual rigor of Minimalist art of the
1960s. At the same time, he adopted the functionalist
ideals of early Modernist architectural and furniture
designs, and his sculptures were created to be used as
social and democratic objects. By the mid-1980s,
Burton was established as one of this country's most
prominent public artists, with commissioned perma-
nent installations in Baltimore, Houston, London,
New York, and Toronto, among other cities.
Granite Settee is shown on page 57.

BUTTERFIELD, DEBORAH (BORN 1949)

Deborah Butterfield was born in San Diego, California,
and has devoted her career to exploring the image of
the horse, and its formal and symbolic implications.
Fascinated by horses since childhood, Butterfield
created her first sculpture of a mare in 1973, using
plaster over a steel armature. Over the following two
decades, Butterfield employed a broad range of
materials as she extended the horse series in many
incarnations. While mostly antinaturalistic, Butter-
field's horses maintain a remarkable sense of realism.
Integral to her working method is her experience of
training horses; her sculptures are animated by an
intimate knowledge of natural posture and movement.
At the same time, Butterfield is acutely aware of the
tradition of equine sculpture, in which stallions
traditionally symbolize masculine and martial power.
In contrast, Butterfield's horses evoke themes of
nurturing and protection as the artist seeks a spiritual
identity with her subject.
Hina is shown on page 53.
Willy, Argus, and Lucky is shown on page 113.

CALDER, ALEXANDER (1898–1976)

Born in 1898 in Philadelphia, Calder was the son and grandson of professional sculptors. After receiving a degree in mechanical engineering from Stevens Institute of Technology in 1919, he worked at many odd jobs and enjoyed a night school drawing class before deciding to become an artist. From 1923 to 1926, he studied in New York at the Art Students League under notable teachers such as Kenneth Hayes Miller, George Luks, Guy Pene du Bois, and John Sloan. In 1926, he went to Paris, where he began making his famous miniature circus and the animated toys that attracted leading figures in the Paris art world. Returning to New York in 1927, Calder had his first one-man show at the Weyhe Gallery in 1928. Calder's transition from representation to abstraction and his use of strong primary colors came as a direct result of a visit to Piet Mondrian's studio in 1930. Marcel Duchamp, who had long been interested in the expression of movement in works of art, visited Calder's studio in 1932 and gave the name "mobile" to his new works. Calder put his training as an engineer into practice, creating subtle balances in the suspended mobile soe the slightest breeze can cause it to move.

Often referred to as the "father of the mobile," Alexander Calder is an American artist internationally renowned for the development of this new idiom in modern art. The mobile serves as an inventive and unique contribution to twentieth-century art that has extended the possibilities of sculpture. Calder's art is direct, buoyant, and colorful, reflecting the witty and playful personality of its creator.
Five Rudders is shown on page 29.
Nenuphar is shown on page 81.

CATLETT, ELIZABETH (BORN 1919)

Born in Washington, D.C., African-American artist Elizabeth Catlett now lives in Cuernavaca, Mexico, and in New York City. She has devoted her artistic career to a socially conscious art that represents the struggles of African Americans and infuses modernism with cultural and historical significance. Her sculptures and prints are well known in the United States and Mexico, where she taught sculpture at Mexico's National University for many years.
Mother and Child is shown on page 48.

COFFIN, DOUG (BORN 1946)

Doug Coffin, of Potawatomi/Creek descent, comes from Lawrence, Kansas. He is best known for his monumental, brightly painted steel and mixed-media sculpture. His style combines ancient totemic forms used by many Native cultures with the abstract geometric forms found in modern art. Coffin has been strongly associated with the Santa Fe Indian art market since the 1970s. His use of bright colors and familiar icons of "Indianness" are a direct result of his Santa Fe experiences.
Earth Messenger Totem is shown on page 90.

DE KOONING, WILLEM (1904–1997)

Willem de Kooning was born in Holland. When Willem was twelve years old, he worked as an apprentice in a commercial art and decorating firm. Members of the firm recommended that he attend classes at the Rotterdam Academy of Fine Arts and Techniques, where he learned about important European Modernists like Picasso and Mondrian. He came to the United States in 1926, and first worked as a house painter in Hoboken, New Jersey. He moved to New York City the following year. In the mid-1930s, he joined the mural painting division of the Federal Art Project of the WPA. He had his first one-man show in 1948 at New York's Egan Gallery, and moved to East Hampton, New York, in the early 1960s, where he lived the rest of his life.
Seated Woman on a Bench is shown on page 74.
Clamdigger is shown on page 104.

DE STAEBLER, STEPHEN (BORN 1933)

Stephen De Staebler was born in St. Louis and attended Princeton University. He received his Master of Arts degree from the University of California at Berkeley. Well known on the West Coast, where he still resides, De Staebler's art is also recognized nationally for his compelling treatment of the figure—fragmented and whole, male and female, composed and distended. De Staebler builds contradiction into his art as he critiques not only the traditions of figurative sculpture from antiquity to the present, but also the human subject on which he focuses.

Standing Figure with Blue Shoulder is shown on page 101.

DEMING, DAVID (BORN 1943)

Born in Cleveland, Ohio, Deming received his B.F.A. in 1967 from the Cleveland Institute of Art, where he is currently Director. He received his M.F.A. in 1970 from Cranbrook Academy of Art in Bloomfield Hills, Michigan, and went on to teach at Boston University School of Fine and Applied Arts and the University of Texas at El Paso. Deming was the head of the Art Department at the University of Texas from 1972 until 1998.

Defender is shown on page 40.

DI SUVERO, MARK (BORN 1933)

Born in Shanghai, China, of Italian parents, Di Suvero emigrated to California at the age of seven. He became a resident of New York City in 1957, where he held his first one-man show. Di Suvero calls his sculpture "painting in three dimensions," and, as such, it is analogous to the wide brushstrokes of Franz Kline and Willem de Kooning.

Pollock's Indians presents Di Suvero's reaction against the Constructivists' massive style of the 1960s, a style more mechanical and artificial than human. His most significant innovation is his choice of materials. Instead of polished and enameled steel, he works with scrap metal, bits of rusty chain, and other such materials. His sculpture contains a generous, open use of space to express buoyancy, balance, and playful movement.

Pollock's Indians is shown on page 38.

DUWYENIE, PRESTON (BORN 1951)

Duwyenie, a Hopi from Northern Arizona, reinterprets the mythology of his tribe through contemporary design using a variety of media including stone, clay, and metal. He was born on Hotevilla, the third of three mesas on which the Hopi people have lived for centuries. His mother was a basket weaver and his father a kachina carver. He studied at the Institute of American Indian Arts and at Colorado State University in Fort Collins, where he graduated in 1984. While working on his master's degree, he accepted a teaching assistantship at Colorado State University. From 1988 until 1995, Duwyenie taught jewelry and traditional pottery at the Institute of American Indian Arts. He now works at his home in Santa Clara Pueblo, New Mexico.

Cloud Stone is shown on page 114.

EDWARDS, MELVIN (BORN 1937)

Melvin Edwards was born in Houston, Texas. He is a well-known sculptor who has, since the 1960s, researched the art and architecture of Africa and the Diaspora. He began making his large-scale, free-standing stainless steel sculptures about 1965. Drawing upon race, culture, and autobiography, Edwards' large steel sculptures often contain significant African and African-American imagery. He has traveled around the world looking for African art in Africa, Europe, and the Americas. Nigeria, Ghana, Mexico, Martinique, Cuba, and France are only a few of the countries he has visited.

Gate of Ogun is shown on page 64.

ERICSEN/QIMMIQSAK, SUSIE BEVINS (BORN 1941)

Susie Bevins Ericsen—or Qimmiqsak, her Inupiat name—is one of the first Native American women artists to extensively explore monumental outdoor sculpture. She works in a mixed media format and has exhibited widely in Alaska and the Pacific Northwest.
Guardians and Sentinels is shown on page 92.

FISHER, JOEL (BORN 1947)

Joel Fisher was born in Salem, Ohio. He graduated from Kenyon College in 1969, and in 1970 began the paper works for which he has become well known. He began exhibiting sculpture when he moved to New York in 1979 and is the recipient of several awards, including a Guggenheim Fellowship in 1993.
Seed (Egg Man) is shown on page 65.

GRAVES, NANCY (1940–1995)

Nancy Graves was born in Pittsfield, Massachusetts, and attended Vassar College and Yale University, where she received an M.F.A.. In 1965, she studied in Paris under a Fulbright–Hayes Grant. Her life of intense work was materialized in more than one hundred solo exhibitions around the world.
Dallaleve is shown on page 71.

HAOZOUS, BOB (BORN 1943)

Bob Haozous, of Apache/Navajo/English/Spanish descent, is one of the most important sculptors in the Native American Fine Art Movement. His innovation and experimentation with materials push the boundaries of Indian art—boundaries that his father, Allan Houser, helped define. Haozous is best known for his monumental cut-steel pieces, which often deal with poignant topical issues. He approaches these issues with a bit of a bite and a good dose of humor, the humor making the serious issues more palatable and lending them a universal presence.

Haozous chose to take back his Apache family name and to reject the Anglo version, Houser, which was given to his father as a child in an Oklahoma Indian boarding school. Together, Haozous and Houser represent the breadth and depth of Native American sculpture.
Woman in Love is shown on page 95.

HASSINGER, MAREN (BORN 1947)

Maren Hassinger was born and raised in Los Angeles. After graduating from Bennington College in Vermont, she received an M.F.A. from the University of California at Los Angeles in 1973. Since 1977, Hassinger has completed more than a dozen public sculpture installations for a variety of organizations and has exhibited widely. All of her sculptures are inspired by nature and by the character of their location.
In a Quiet Place is shown on page 60.

HAVEL, JOSEPH (BORN 1954)

Born in Minneapolis, Minnesota, Joseph Havel is a master of poetic allusion, balancing found materials and exquisite craftsmanship to create wittily animated abstract sculptures. Shortly after completing his studies, Havel moved to Texas, where his work drew inspiration from the rural landscape. Building upon the tradition of Surrealist assemblage, Havel used familiar implements, tools, and fragments of furniture to reflect the common vernacular of the region in which he worked.

In more recent years, Havel has concentrated on less localized images, creating works which contain multiple references. In 1986, he cast his first sculpture in bronze, a medium which has played a key role in the evolution of his work. Direct-casting techniques allowed Havel to continue to incorporate everyday objects into his work, while the tensile strength of the new medium gave a fresh dynamism to his compositions. Over the past decade, Havel has continued to work in bronze as well as in more ephemeral materials.
Exhaling Pearls is shown on page 55.

HEPPER, CAROL (BORN 1953)

Working in relative obscurity on a ranch on an Indian reservation in South Dakota, Carol Hepper came to the attention of curators at the Guggenheim Museum for her large-scale sculptures made from materials indigenous to her surroundings—animal hides, fish skins, and willow branches.

When she moved to New York City in the early 1980s, Hepper continued to work with materials—twisting, bending, and weaving hides and willow saplings. During the following decade, influenced by the surroundings of the city, she integrated man-made materials with the organic, incorporating copper tubing and metal fittings traditionally used for plumbing and construction.

Hepper continually juxtaposes ideas and materials in her work. In form, the copper tubing recalls the twisting, bound strands of willow branches, alluding to nature, while the material itself is man-made. The images she creates could be seen as metaphors for the underground circuitry for a house, or city, or even the internal circuitry of the body. *Vertical Void* is shown on page 45.

HOFFMAN, MALVINA (1885–1966)

One of the most popular sculptors of her time, Malvina Hoffman employed strong modeling and a vigorous realism to depict a wide variety of subjects. Reared in New York City, she trained there with Gutzon Borglum and Herbert Adams before intermittently studying with Rodin in Paris from 1910 to 1914. Rodin advised her, as she later recorded: "Do not be afraid of realism. To understand nature is a lifelong study." To this end, she learned anatomy at the Cornell College of Physicians and Surgeons as a method of improving her ability to sculpt the human body. While in Paris, Hoffman belonged to a circle that included Nijinsky, Anna Pavlova, Gertrude Stein, Henri Matisse, and Constantin Brancusi.

Hoffman's most famous commission was for *The Races of Man*, a series of over one hundred artistic eth-nography sculptures completed for the Field Museum of Natural History in Chicago in 1935. After receiving the commission in 1929, she toured the world to study various peoples. She received numerous prizes for her exhibited works, including ones from the National Academy of Design in New York, the Pennsylvania Academy of the Fine Arts, and the Paris Salon. Several women's groups also honored her for her achievements. In 1936 she published her autobiography, *Heads and Tales*, and in 1939 the book *Sculpture Inside and Out*. *Ivan Mestrovic* is shown on page 103.

HOLLEY, LONNIE (BORN 1950)

The seventh of twenty-seven children, African-American sculptor Lonnie Holley was born in Birmingham, Alabama. His childhood was spent primarily in foster homes and reform schools. In 1979, this self-taught artist began his career when he used discarded sandstone from a nearby industrial complex to carve tombstones and other figures.

Holley is best known for his sculptural collages of found objects. A concern with recycling cast-off materials is visible in his work, and his pieces incorporate objects gathered from garbage dumps, sites of fires, and vacant lots, such as telephone and electrical wire, fabric, old shoes, and household appliances. He now lives and works in Birmingham in a two-acre outdoor studio of his own making, which surrounds its visitors with his creations. *Leverage* is shown on page 43.

HOOVER, JOHN (BORN 1919)

John Hoover, an Aleut, is a contemporary of Allan Houser and credits Houser with encouraging his work. Houser recommended Hoover for a teaching position at the newly established Institute of American Indian Art (IAIA) in the early 1960s. Hoover and Houser also shared the same gallery and dealer, and their careers grew together.

Each artist did, however, work with the subject he knew best—his own cultural heritage. Hoover was born and reared in Alaska. Like many Aleut young men of his generation, he became a commercial

fisherman, and he continues to fish the cold waters of Alaska during the season. The images he incorporates into his sculptures are from the stories and histories of the peoples of Alaska. His themes are connected to the relationship between man and the spirit world. His work has often been referred to as shamanistic; many of his pieces are representations of this state of transformation.

Sea Weed People is shown on page 91.

HOUSER, ALLAN (1914–1994)

Allan Houser, a Chiricahua Apache, has been referred to as the grandfather of contemporary Native American sculpture. He has without question had the most influence in establishing the canons of Native sculpture. He was a member of the 1962 inaugural faculty at the Institute of American Indian Art (IAIA), and during his years there taught hundreds of students about sculpture. Many of his themes are based on stories he heard from his father about the lifeways of the Apache people before the coming of the Europeans. Houser blended the influences of the Mexican muralists with the sculptural designs of British artist Henry Moore to create his distinctive "Indian" sculptural style.

As a young man, Houser began his formal art training at the Santa Fe Indian School in a newly formed studio class. The class was taught by a young Chicago Art Institute graduate and became known as "The Studio." Houser and the students of The Studio became known for their distinct painting style of pastel colors that were outlined to create a flat, two-dimensional quality. This style of painting later became known as "Traditional Indian painting." At the height of his painting career, Houser began to experiment with three-dimensional media, first with wood carvings and later working in stone and bronze. He was commissioned in 1968 to create his first monumental piece for Haskell Indian College in Lawrence, Kansas.

Earth Song is shown on page 86.

HUNT, BRYAN (BORN 1947)

Bryan Hunt, a sculptor, draftsman, and photographer, was born in Terre Haute, Indiana. He studied at the Otis Art Institute in Los Angeles, and later was accepted into the independent study program at the Whitney Museum of American Art in New York City. His works are in cast bronze, and he uses both the ancient, time-consuming lost-wax method and the faster though rougher sand-casting method. While the artist was studying art in the early 1970s, sculpture was dominated by abstract styles concerned with formal qualities such as balance and purity of line. Hunt rejected this style, seeking instead to create sculptures that combine formal concerns with recognizable imagery drawn primarily from the natural world.

Shift Falls is shown on page 26.
Big Twist is shown on page 105.

HUNT, RICHARD (BORN 1935)

Born and reared in Chicago, Richard Hunt, an African-American, showed precocious talent. After attending the Junior School at the Chicago Art Institute as a teen, he enrolled as a full-time scholarship student in 1953. While earning his bachelor's degree in Art Education, he discovered the innovative welded-iron sculptures created in the 1930s by the Spanish modernist Julio Gonzalez. Hunt was further impressed by the organic forms and Surrealist motifs in David Smith's welded-steel sculptures. Hunt quickly developed his own style of abstract, constructed metal sculpture which emphasized linear forms in open compositions, with a tendency toward jagged shapes and dramatically expressive rhythms. By 1955, the Museum of Modern Art in New York had acquired one, followed by the Chicago Art Institute in 1958. By the 1970s, his works emphasized mass and forms that rest solidly on the earth. He worked increasingly in bronze, in a gracefully organic, abstract style descended from the biomorphism of the Surrealists. In 1962, Hunt received a Guggenheim fellowship, followed by a Ford Foundation Award in 1965.

Farmer's Dream is shown on page 34.
Large Hybrid is shown on page 77.
Icarus is shown on page 112.

HYDE, DOUG (BORN 1946)

Doug Hyde, of Nez Percé/Assiniboine/Chippewa descent, studied with Allan Houser at the Institute of American Indian Art (IAIA) in the mid-1960s, during its peak as "the" Indian art school. He adopted the Houser style of sculpting, which is distinctive for its heavy curved forms, fluid lines, and foreshortened bodies with oversized hands. Hyde has successfully maintained and continued the Houser style.
Flag Song is shown on page 85.

KELLY, ELLSWORTH (BORN 1923)

Ellsworth Kelly was born in 1923 in Newburgh, New York. During the Second World War, he was assigned to the 603rd Engineers Camouflage Battalion and was stationed at Camp Hale, Colorado. From 1946 to 1948, he studied at the Boston Museum School. He then went to France and continued studies at the Ecole des Beaux Arts in Paris. Returning to New York in 1954, he began a career that would prove him an artist of outstanding quality and a radical innovator.

Kelly is best known as one of the most important post-war abstract painters. Kelly's subjects are, on one level, formal investigations of the properties of simple geometric shapes and colors. In generating his sculptures, he uses patterns and shapes from his drawings, building upon the spatial breadth between objects in the composition and the shapes created by negative space.
Curve VIII is shown on page 33.
Untitled (EK 680) is shown on page 118.

KING, WILLIAM (BORN 1925)

William King, born in Jacksonville, Florida, now lives in East Hampton, New York. In the early stages of his career, King worked predominantly in carved and painted wood, clay, terra cotta, and bronze. He began moving toward his more familiar plate-metal pieces in the early 1960s. For *Adolescence*, King used cast aluminum for the figure's face and hands, giving the slightest suggestion of ears, cheekbones, eye sockets, knuckles, and skin creases. Aluminum plates cut with a jigsaw created the remaining portions of the figure.
Adolescence is shown on page 37.

LACHAISE, GASTON (1882-1935)

Born in Paris, Gaston Lachaise trained as a sculptor at the Ecole Bernard Palissy and the Academie Nationale des Beaux Arts. He moved to Boston in 1906 and to New York in 1912, where he assisted the sculptor Paul Manship. He had many friends in the literary and intellectual world of New York who helped him secure portrait commissions. Exhibiting with Alfred Stieglitz in 1927, Lachaise began to receive important public commissions, such as those for RCA and the Rockefeller Center in New York, and the World's Fair Exhibition in Chicago.

His most important pieces, however, are the public monumental female figures, which have been compared to those of Renoir and Maillol. While the French artists' works constitute the essentially classical and French tradition of the intellectualized perfection of form, Lachaise's figures represent the celebration of a sensory and at times sensual idea of the human form. He was the first sculptor to be afforded a retrospective exhibition at New York's Museum of Modern Art. Lachaise's untimely death in 1935 brought to an end one of the most adventurous imaginations in American art.
Standing Woman is shown on page 30.

LICHTENSTEIN, ROY (1923–1997)

Roy Lichtenstein was born in New York City. A quintessential proponent of Pop Art, he is known for making "high" from "low" sources, borrowing imagery from popular culture and reinterpreting it in light of the traditions of fine art. During his last year of high school, Lichtenstein studied with Reginald Marsh at the Art Students League in New York City. He earned both his B.F.A. (1946) and his M.F.A. (1949) degrees from Ohio State University. In 1949, he had his first one-man exhibition at the Ten-Thirty Gallery in Cleveland. Lichtenstein lived in Cleveland from 1951 until 1957, working as a commercial artist and designer. From 1957 to 1961, he was an Assistant Professor at the State University of New York, Oswego, and later taught at Rutgers University. In 1963, Lichtenstein moved back to New York City, and in 1967, he executed his first modern sculptures.
Untitled Head I is shown on page 82.

LIPSKI, DONALD (BORN 1947)

Donald Lipski was born in Chicago. He studied at the University of Wisconsin, Madison, and the Cranbrook Academy of Art, Bloomfield Hills, Michigan, where he received his M.F.A. He has always been interested in magic, and in most of his work he acts as a visual magician, playing with the interpretation of the objects he uses in his sculptures.

The influence of Minimalism is most evident in Lipski's works after 1985, when he began making large and monumentally scaled pieces. He includes a variety of objects, some of them "found" materials and industrial debris, others which are commonly used in daily life.
The West is shown on page 69.

LOBE, ROBERT (BORN 1945)

Robert Lobe, who was born in Detroit and lives in New York City, has a studio in the woodlands of New Jersey. The contrast between the two environments—one containing much concrete, glass, and steel; the other natural and idyllic—has had an impact on his work. Works such as *Harmony Ridge #26* exemplify this combination of industrial material and naturalistic method: Using a pneumatic hammer at 2,000 blows per minute, Lobe molds the aluminum in the manner of a potter sculpting clay.
Harmony Ridge #26 is shown on page 63.

LOWE, TRUMAN (BORN 1944)

Truman Lowe, of Winnebago descent, has established himself as an innovator in Native-American sculpture, successfully translating the elegance of traditional wood use by his Winnebago ancestors into his contemporary sculptures. His monumental wood sculptures masterfully echo the ancient ceremonial mounds and effigies of the peoples from the Woodlands area of the United States, capturing the essence, beauty, and spirit of these ancient forms.

Lowe began experimenting with metal as a medium by creating smaller bronze pieces directly from his wooden pieces. He has also been fabricating his monumental pieces directly from his designs, using aluminum instead of wood.
Bird Effigy is shown on page 88.

MANGOLD, ROBERT (BORN 1937)

Born in Houtinberg, Indiana, Robert Mangold received his M.F.A. from Indiana University in 1960. He served as an Air Force radio repairman and engineer before turning to the making and teaching of art. He is a professor at the University of Denver and at Metropolitan State College. His large kinetic works are a familiar sight in the Denver landscape, at the Museum of Outdoor Arts and on the Metro State Campus. His outdoor sculptures deal with time, space, and motion; all look as though they move, even when they do not.

Mangold has played a major role in developing the Denver contemporary art scene by serving on the Mayor's Commission of Art, Culture and Film; the Denver Parks Foundation; and the Denver Botanic Gardens Acquisition Committee.
Windsong III is shown on page 109.

MANSHIP, PAUL (1885–1966)

Born in St. Paul, Minnesota, Paul Manship began his artistic study at the St. Paul Institute of Art, preparing for a career as an illustrator. Deciding instead to become a sculptor, he moved to New York and studied at the Art Students League. In 1909, he won the Prix de Rome, enabling him to spend three years at the American Academy in Rome, where he was greatly inspired by Renaissance sculpture and archaic Greek art. This strong classical influence is much more pronounced in Manship's work than the Realism he had been taught in the academies. When he returned to New York, Manship enjoyed great success and received many important commissions. After falling out of favor in the late 1940s because of the preeminence of abstract art and disdain for figural work, Manship is again highly respected. His work consists mainly of portraits and of mythological sculptures, all done in a Neoclassical style.
Diana and *Actaeon* are both shown on page 35.

MCCOLLUM, ALLAN (BORN 1944)

Allan McCollum was born in Los Angeles. In his work, he explores the question of the seductive, marketable nature of objects by using them in different ways from those originally intended. An ordinary vase, for example, becomes an art object when it can no longer hold liquid. The artist states that the objects "need only to function as signals, signals directing one to lapse into a particular state of mind, a state which one reserves especially for one's aesthetic adventures."
Perfect Vehicles is shown on page 70.

MOROLES, JESÚS BAUTISTA (BORN 1950)

Jesús Bautista Moroles was born in Corpus Christi, Texas. In 1978, he received a B.F.A. from North Texas State University, Denton, following studies at the U.S. Air Force Electronics School in Biloxi, Mississippi, and El Centro College in Dallas. In 1979 and 1980 he lived in Italy, studying classical stonecutting techniques in Pietrasanta, near Carrara. Returning to Rockport, on the Texas Gulf Coast, Moroles began to work in the variously colored granites of the region. Granite has continued to be his chief material over the past fifteen years, his totemic sculptures evoking ancient cultures. Using state-of-the-art stonecutting techniques, Moroles manipulates granite with extraordinary authority, creating works which appear to contradict the mass and weight of the material.
Moon Ring 3 is shown on page 50.

MORRISON, GEORGE (BORN 1919)

George Morrison, an Ojibway, works in an abstract style that was nurtured at the Art Students League in New York City during the 1940s, but he also draws on his childhood memories of growing up on the northern banks of Lake Superior. Often his work references the horizon line, a recurring theme that gives his work structure and identity and has become his signature.
Red Totem is shown on page 93.

NARANJO-MORSE, NORA (BORN 1953)

Nora Naranjo-Morse was born in Santa Clara and belongs to a family of gifted Tewa artists. Her mother and one sister are highly regarded Santa Clara potters, and her brother Michael is a well-known sculptor who encouraged Nora to work in bronze as well as in clay. Her works are in public and private collections throughout the country. She is also known as a poet and filmmaker.
Khwee-seng (Woman-man) is shown on page 84.

NERI, MANUEL (BORN 1930)

Manuel Neri was born in 1930 in Sanger, California into a Hispanic (Mexican-American) family. He became interested in art when he took an elective ceramics course while pursuing a degree in engineering. Deciding to pursue a career as an artist, he enrolled at the California College of Arts and Crafts in 1951,

transferring to the California School of Fine Arts (now the San Francisco Art Institute) in 1957 after two years of military service in Korea. Through his studies, he was exposed to both the rich artistic traditions of Bay Area figurative painting and the ideology of West Coast Abstract Expressionism.

In the late 1950s, Neri became one of the first artists to combine figurative sculpture with Expressionist artistic techniques, evident in the bold slashes of color that are often found on his figures. He has always retained the figure in his work because to him it conveys a sense of spirit. The chosen medium in his early works was plaster because it was easy to mold and responded well to his spontaneous technique. Since the mid 1970s, Neri has devoted part of each year to making marble sculptures in Carrara, Italy. He "distresses" the surfaces with chisel blows, making areas of texture that contrast with smoothed and highly polished areas, occasionally overpainting with vivid color.

Aurelia No. 1 is shown on page 31.
Untitled is shown on page 110.

NEVELSON, LOUISE (1899–1988)

Louise Nevelson was born Louise Berliawsky in Kiev, Russia. Her family immigrated to the United States and settled in Rockland, Maine, in 1905. By the age of nine, she knew that she would become an artist. After marrying and moving to New York in 1920, Nevelson began to study the performing and visual arts at the Art Students League. When her marriage ended in 1931, Nevelson traveled to Munich to study with the prominent painter and teacher Hans Hofmann. She continued her studies with Hofmann in New York, where she also worked as an assistant to the Mexican muralist Diego Rivera, and as an art teacher for the Works Progress Administration. Nevelson turned to sculpture in the mid-1930s. Her works from the 1930s and 1940s were small Cubist figural sculptures, shaped in various materials—stone, terracotta, plaster, wood, and occasionally cast in metal. By the mid-1950s, Nevelson was exhibiting works in her mature style— modular cratelike forms stacked to create columns, walls, or entire environments constructed with wooden objects, mostly found objects such as moldings and balusters from buildings that were being demolished.

These constructions were usually monochromatic, often painted black, white, or gold.

In the 1960s, when Louise Nevelson began making outdoor sculpture, she began using steel and aluminum to make monumental sculptures that were fabricated at the Lippencott Foundry in Connecticut. *Chapel II* is shown on page 60.

NOGUCHI, ISAMU (1904–1988)

Isamu Noguchi was born in Los Angeles. His father was a Tokyo-born poet and his mother an American writer and teacher. In 1922, when Noguchi was 18 years old, he apprenticed in Stanford, Connecticut, with Gutzon Borglum, the sculptor of Mount Rushmore. Borglum apparently told Noguchi that he would never become a sculptor, causing him to abandon sculpture and enroll at Columbia University as a pre-med student. However, during his time in New York, he returned to sculpture.

Noguchi traveled internationally, and European, Asian, and Middle Eastern sources inspired his work. His selection of diverse materials and his nonhierarchical study of varied disciplines enabled his *oeuvre* to incorporate types of "non-art" work. He made theater sets for Martha Graham, outdoor public works like bridges and playgrounds, and decorative arts objects like coffee tables and lamps, as well as the sculpture for which he is best known. Noguchi's examination of the figure extends from his earliest sculpture to his late work. Art historians have placed the artist in line with Constantin Brancusi and Rodin, each of whom abstracted the essence of the human form in their sculpture.

Noguchi's art is notable also for its astonishing versatility and pervasive tension between Asian and European sensibilities, the figurative and the abstract, the personal and the universal.

Great Rock of Inner Seeking is shown on page 75.
Woman is shown on page 99.
Remembrance is shown on page 119.

O'CONNOR, ANDREW, JR. (1874–1941)

Andrew O'Connor was born in Worcester, Massachusetts, where he received his initial training from his father. He subsequently studied with William Ordway Partridge in Chicago before moving to London in 1894 to serve as a model for John Singer Sargent. Upon returning to America in 1897, O'Connor trained with Daniel Chester French in New York, where he received the first of many public commissions—for the bronze doors of St. Bartholomew's Church in New York. Others include a statue of General Henry Lawton for Indianapolis, Indiana, which won a gold medal at the Paris Salon of 1906; two monuments to Abraham Lincoln, one of which is in Springfield, Illinois; and a statue of General Lafayette for the city of Baltimore.

In about 1904, he moved to Paris, where he stayed until 1914. During this time he made the acquaintance of Rodin, an exposure that undoubtedly helps to account for the expressive quality of his sculptures. He exhibited frequently, including at the Venice Biennale, the Pan-American Exposition in Buffalo (where he won a bronze medal), and in Barcelona, where he received a silver medal. His sculpture *Tristram and Iseult* won a gold medal at the Salon des Artistes Français in Paris in 1928. O'Connor died in Dublin.
Tristram and Iseult is shown on page 100.

O'KEEFFE, GEORGIA (1887–1986)

Georgia O'Keeffe, who was born in Sun Prairie, Wisconsin, is among the pioneering figures of American art. Following studies at the Art Students League, University of Virginia, and Columbia University's Teachers College, she began a teaching career which ultimately took her to Canyon, Texas. In 1915, she created a series of extraordinary abstract compositions that captured the attention of Alfred Stieglitz, photographer and gallery owner, who promoted O'Keeffe through exhibitions and writings.

The two formed a friendship following their first meeting in 1916, and in 1918 O'Keeffe took up residence in New York, where she became Stieglitz's companion.

Over the following three decades, she divided her time between the East Coast and the Southwest. This division is reflected in her work, which celebrated both urban and desert landscapes. In 1949, O'Keeffe made New Mexico her permanent home, living in Abiquiu and Ghost Ranch, north of Santa Fe. O'Keeffe died at the age of 98.

While best known for her paintings and exquisite drawings, O'Keeffe created several abstract sculptures at different stages in her career. These works echo the imagery of her paintings, portraying organic and blossoming forms.
Abstraction is shown on page 52.

OLDENBURG, CLAES (BORN 1929)

Claes Oldenburg, one of the most important sculptors associated with Pop Art, was born in Stockholm in 1929. He came to America with his family in 1936, settling in Chicago. After graduating from Yale University in 1950, he returned to Chicago, where he worked as a newspaper reporter. Switching his focus to art, he studied at the Art Institute of Chicago from 1952 to 1954. In 1956 he moved to New York City, where he soon became part of the artistic scene in which Happenings and Pop Art developed. Oldenburg's monumental sculptures celebrate the significance and beauty of everyday things—often making subjects much bigger than life.
Clothespin—4 Foot Version is shown on page 120.

OTTERNESS, TOM (BORN 1952)

Tom Otterness was born in Wichita, Kansas, and attended classes in New York at the Art Students League and The Whitney Museum of American Art's Independent Study Program during the 1970s. In 1977, he became a founding member of Collaborative Projects, Inc., a group of 50 socially engaged young artists. Since 1987, he has devoted most of his time to public art and has received many important public commissions in the United States and Europe.
Head is shown on page 67.

PEPPER, BEVERLY (BORN 1924)

Beverly Pepper has been living in New York City and Italy since 1951. Inspired to become a sculptor by the temples of Angkor Wat and surrounded in Italy by antique and medieval ruins, Pepper has been concerned throughout her career with archetypal forms, suggestive of ceremony.

Ternana Altar II is part of a series of what she calls "urban altars"—monumental objects that evoke primeval ritual through their sense of brutality and massiveness.

Ternana Altar II is shown on page 44.

PURYEAR, MARTIN (BORN 1941)

Martin Puryear was born in Washington, D.C. He draws upon ethnography, popular culture, and history as sources for his brilliantly evocative sculptures. After graduating from the Catholic University of America in Washington, D.C., in 1963, he spent two years with the Peace Corps in Sierra Leone, West Africa. He then continued his studies at the Swedish Royal Academy of Art, Stockholm, and received his M.F.A. from Yale University in 1971. While in Africa, he became fascinated by the ongoing traditions of local craft and construction that have spanned more than one thousand years; many of the techniques of his subsequent work were based on his African experience.

Through his studies at Yale, Puryear assimilated the history of Modernism, from the first decades of the twentieth century to Minimalism. Typically, his sculptures evoke man-made tools and forms found in nature. By reducing these forms to simple and elemental shapes, Puryear creates archetypal images that appear to be timeless.

Decoy is shown on page 56.

RICKEY, GEORGE (BORN 1907)

Born in South Bend, Indiana, George Rickey spent his childhood and youth in Scotland. He had an early aptitude for mechanical devices and their principles—an ability perhaps inherited from his father, a mechanical engineer, and his grandfather, a clockmaker. Although he began his artistic career as a mural and fresco painter, he made his first mobile sculpture in 1945 while serving in the Air Force and, by 1949, was making Constructivist mobiles. Since the 1950s, Rickey has explored the essence of movement through his kinetic sculptures.

Two Lines Oblique, Atlanta is shown on page 46.
Two Open Trapezoids Excentric V is shown on page 111.

RODIN, AUGUSTE (FRENCH, 1840–1917)

Auguste Rodin occupies a pivotal position in the history of sculpture. Straddling two centuries, his life's work takes its place in the long-standing classical tradition established by the French Academy, while at the same time setting the stage for important twentieth-century innovations. He strove for success within the established framework of government-sponsored exhibitions and commissions, yet refused to compromise his unconventional ideas about art.

Although Rodin worked with the usual materials of sculpture (clay, plaster, bronze, and marble), he handled them in an entirely new way. Instead of trying to smooth away evidence of the sculptural process, he often chose to retain the seams, toolmarks, fingerprints, areas of breakage, and excess deposits of the medium. Similarly, although many artists of the nineteenth century admired the sculptural fragments of antiquity, none before Rodin dared to create a partial figure and declare it a self-sufficient work of art. Rodin purposefully omitted elements, such as arms, when not essential to the expression he sought to achieve—something his contemporaries found difficult to accept. Nonetheless, his consistent use of the human figure attests to his respect for, and commitment to, tradition.

While Rodin often took allegorical, mythological, literary, or historical themes as his subject, his goal in portraying them marked a significant departure from his predecessors. Like the Symbolist writers and artists who were his contemporaries, he sought to communicate the invisible by means of the visible. Character, emotion, and thought could all, he felt, be read in the pose, expression, and physical structure of a figure. Rodin believed that nature, being a creation of God, could produce only beauty: He who saw ugliness in nature saw wrong. Whereas age, deformity, and accident were banished from the Academic canon of beauty, Rodin proclaimed that these had their place and that true artists transformed such aspects into eloquent affirmations of nature's splendor.

The multifaceted character of Rodin's art, its simultaneous endorsement and disavowal of cherished Academic principles, places him at the nexus between tradition and modernity in sculpture. The implications of Rodin's ideas have fueled many interesting and important developments in the twentieth century, earning him the well-deserved title "father of modern sculpture."

The Three Shades is shown on page 102.

The Thinker is shown on page 106.

Memorial Relief (Hand of a Child) is shown on page 107.

ROOSEN, MIA WESTERLUND (BORN 1942)

Mia Westerlund Roosen was born in New York City. She has always made large-scale sculpture. Her pieces often have an organic inspiration, and are made to be shown outdoors, in a natural landscape, through a process that the artist thinks of as a "marriage." The landscape helps to soften the materials of the sculpture, a hard bronze, which is identified with architecture, industry, and the man-made.

Triple Disc Bronze is shown on page 68.

SAAR, ALISON (BORN 1956)

African-American artist Alison Saar was born in Los Angeles. Her mother, Betye Saar, a nationally known artist, and her father, Richard, a conservator, encouraged her interest in working with found objects and with traditional materials and techniques. She studied art history at Scripps College, where she researched African, Afro-Cuban, Haitian, and other Black visual traditions.

Snake Charmer is shown on page 47.

SAMARAS, LUCAS (BORN 1936)

Born in Macedonia, Greece, Lucas Samaras moved to the United States in 1948. He studied at Rutgers and Columbia Universities. Through the years, he has worked with a diverse range of materials, from oil painting to film to photography to clay. In 1970, he started producing "boxes" in a variety of metals that defy the idea of container by changing and abstracting the box forms.

Stiff Box No. 12 is shown page 62.

SCOTT, JOHN (BORN 1940)

An African-American artist from New Orleans, John Scott is a professor in the art department at Xavier University. He is perhaps best known for his vibrantly colored, abstract sculptures, many of which are designed to move. His work combines the improvisational energy of his native New Orleans jazz with a studied, refined embrace of Western art, and unites African and American culture.

Target I is shown on page 42.

SEGAL, GEORGE (BORN 1924)

George Segal was born in New York City. He studied at The Cooper Union, Rutgers University, and Pratt Institute before receiving his degree in art education from New York University. Segal originally worked as a painter, exhibiting Expressionist figure paintings at his first one-man show in 1956 at the Hansa Gallery, an

artists' cooperative in New York. Segal began experimenting with sculpture in 1958, creating bas-relief figures in plaster, wire, and burlap. By 1960, he had begun creating his now-familiar sculptures of anonymous figures either alone or in tableaux containing objects. Using his family and friends as models, Segal created these figures with a direct casting technique utilizing plaster-soaked bandages. He does not use pedestals, but places his figures on the same level as the viewer.
Walking Man is shown on page 25.
Girl Standing in Nature is shown on page 98.

SHAPIRO, JOEL (BORN 1941)

Joel Shapiro was born in New York City. He studied at New York University, where he received a B.A. in 1964 and an M.A. in 1969. In between degrees he went to India, where he served in the Peace Corps from 1965 to 1966. He has taught at Princeton University (1974–76) and at the School of Visual Arts in New York (1977–82). Shapiro is the recipient of a National Endowment for the Arts grant (1975), the Brandeis University Creative Arts Award (1984), the Skowhegan School Medal for Sculpture (1986), and the Award of Merit Medal for Sculpture from the American Academy and Institute of Arts and Letters (1990).

Shapiro takes architecture and the human figure as points of reference in his wittily reductive sculptures. His first works from the early 1970s emphasized the process of assembly, and were made up of units which appeared to be arranged haphazardly. In the mid-1970s, he began to create a series of small-scale geometric sculptures using recognizable and ordinary images such as houses, chairs, and tables; by 1980, the human figure had become a dominant motif in Shapiro's work.

Over the following decade, the artist has continued to experiment with the figure, frequently working on a monumental scale. Using simple block forms, Shapiro creates figures which look like puppets or sculptor's models. Typically, they are presented with limbs akimbo in asymmetrical and gravity-defying positions. These deceptively simple works unite both Constructivist and figurative traditions with extraordinary sophistication.
Untitled (1982) is shown on page 54.
Untitled (1989) is shown on page 76.

SHAY, ED (BORN 1947)

Ed Shay, born in Boston, is primarily a painter. *Acadian Gyro* is only the third formal piece of sculpture he has created since graduating from the University of Illinois Master of Fine Arts Program in 1971. He does, however, often conceive his work in three dimensions before making his large-scale oil paintings.

Receiving his third NEA Fellowship in 1985 enabled Shay to work in cast metal, as in *Acadian Gyro*, creating latex and plaster molds from sticks found in his backyard.
Acadian Gyro is shown on page 61.

SHEA, JUDITH (BORN 1948)

Judith Shea was born in Philadelphia. She obtained a fashion design degree in 1969 at the Parsons School of Design, New York. Through her interest in clothing as structure, and the then-current Pattern and Decoration movement in the art world, Shea began to create abstracted bodice forms made of organza, taffeta, and canvas. Over the next few years, she began to construct clothes and soak them in a variety of stiffening media in order to create three-dimensional forms. Shea earned her B.F.A. from a joint program at Parsons and the New School for Social Research in 1975 and began teaching as well as sculpting. A class in medieval European armor at the Metropolitan Museum of Art gave the artist the idea of casting her work in metal, first in iron in 1982, and then in bronze from 1983. That year she also visited Greece, where she was influenced by Classical sculpture.

Shea has received numerous awards and prizes, including the Rome Prize by the American Academy in 1994. She lives and works in New York City.
Shield is shown on page 32.
Post-Balzac is shown on page 72.

SMITH, DAVID (1906–1965)

David Smith was born in Indiana. After a few art classes in high school and at Ohio University, he moved to New York in 1926 to study painting and drawing at the Art Students League. Under Jan Matulka's tutelage from 1928 to 1931, Smith was profoundly influenced by Cubism. In 1927, he married sculptor Dorothy Dehner, and two years later they bought a farm at Bolton's Landing in upstate New York, where they would move to live full-time in 1940. In 1932, inspired by photographs of sculptures by Pablo Picasso and Julio González, Smith began to construct welded metal works. A trip to Europe in 1935 to 1936 provided new sources of inspiration, notably the biomorphic forms and imaginative subjects of Surrealism. From the later 1930s through the early 1950s, Smith sculpted compositions with evocative and mysterious themes, using shapes that became increasingly abstract.

Supported by a Guggenheim fellowship in 1950–52, Smith concentrated intensely on his work, producing a flood of innovative sculptures. During this decade, his works received widespread critical acclaim as the sculptural counterparts of Abstract Expressionist painting. By the time of his death, he was widely acknowledged as one of the most significant sculptors of the twentieth century.

Cubi XXVI is shown on page 41.
Agricola I is shown on page 73.
Voltri XV is shown on page 79.

STONE, WILLARD (1915–1985)

Willard Stone, half Cherokee and half Irish/German, was born in Oktaha, Oklahoma, and lived for most of his life in Locust Grove, Oklahoma. During the 1940s, he developed a style unique to Oklahoma and to Native American contemporary art. Stone worked as a die finisher at McDonnell Douglas Aircraft Plant in Tulsa, before retiring in 1960 to devote himself to his art full time. Stone produced exquisite wood sculptures that are both modern and decorative, often containing religious themes.

Lady of Spring is shown on page 89.

STORRS, IMMI (BORN 1945)

Immi Storrs trained at the University of Denver, the Art Students League in New York, and in Florence, Italy. She was active as a painter during the 1970s, when she exhibited widely in the United States and in Germany. Her first sculpture exhibition occurred in Boston in 1980. Since then, she has exhibited in both solo and group shows across the United States and in Germany. She has received awards from various arts organizations, including the National Academy of Design, the Art Students League, the National Arts Club, and the E.D. Foundation. Storrs lives and works in New York City.

Five Horses is shown on page 83.

SWENTZELL, ROXANNE (BORN 1963)

Roxanne Swentzell is the niece of Nora Naranjo-Morse and is also well grounded in the realm of Santa Clara pottery produced by her grandmother, mother, and aunts. She has developed a style of realistic figurative sculpture derived from the ancient abstract effigy forms of her Pueblo ancestors. Her knowledge of the human form, more specifically the Pueblo body, is evident. Her technique is true to the ancient coil and scrape method of pot building, but she takes that method to another level with the use of sculpting tools to define her human forms.

The Emergence of the Clowns is shown on page 94.

THERRIEN, ROBERT (BORN 1947)

Robert Therrien invests common geometric forms with visual wit and a sense of play. Born in Chicago, by the mid-1970s he had established a basic lexicon of forms from which he created an extended series of sculptures varying in scale, material, and color. Rendered both as reliefs and as freestanding sculptures, these works, in their geometric purity, are allied with Minimalist aesthetics. At the same time, each work can be read as a familiar image, such as a church, a snowman, a bent dunce's cap, or a keyhole, recalling the bold simplicity of children's book illustrations.

No Title is shown on page 51.

TUCKER, WILLIAM (BORN 1935)

William Tucker creates abstract sculptures that combine formalist concerns with an astute sense of material. Born in Cairo, Egypt, to English parents, Tucker was reared in England. He emigrated to the United States in 1978 and became an American citizen in 1986. In the 1960s and 1970s, his work was mostly analytic in nature, characterized by a spare geometry. As his work evolved into the early 1980s, his compositions were pared down to reductive armatures and delicate silhouettes, exploiting the tensile strength of his materials—typically steel or wood. In the mid-1980s, however, Tucker began to work in bronze, plaster, and clay. The malleability of these materials prompted a shift in his sculpture, which took on a new mass and weight.

Track is shown on page 49.

VAADIA, BOAZ (BORN 1951)

Born in Israel, Boaz Vaadia has resided in New York City since 1975. His multilayered sculptures look ancient, as though centuries of wind or water have chiseled them out of the rocks. Vaadia's materials—slate, shingle, bluestone, and boulders—are from the immediate area surrounding his New York studio. He is drawn to these materials because of their ancient ties to the land and their continued use in contemporary civilization. Slate and bluestone are sedimentary rocks formed millions of years ago, and are heavily used today throughout New York City in roofing and housing projects.

Vaadia carves each individual piece of stone with a hammer and chisel, exposing the stratified layers of stone. He stacks these stones to create his forms. His process parallels natural transformations in stone, and also recalls ancient methods of construction that relied on the cut and weight of the stone rather than on mortar. He then glues or bolts the stones in his sculptures together for safety and security.

Zur with Dog is shown on page 39.

WEINMAN, ADOLPH (1870–1952)

Adolph Weinman was among the last generation of sculptors identified with the American Renaissance. Born in Karlsruhe, Germany, he emigrated to the United States with his family in 1880. He attended Cooper Union and the Art Students League, completing his studies under Augustus Saint Gaudens. By 1900, he had established a career as a popular sculptor of figures and decorations for public monuments; he was also active as a medalist. Among his most celebrated works are the fountain figures of *Rising Sun* and *Descending Night* that he created for the 1915 Panama–Pacific International Exposition in San Francisco to celebrate the opening of the Panama Canal. His public commissions in Washington, D.C., include the decoration on the pediment of the Thomas Jefferson Memorial, the monumental frieze for the Supreme Court Room in the Supreme Court Building, and the facade decorations of the Post Office Department Building.

Rising Sun is shown on page 58.
Descending Night is shown on page 59.

WITKIN, ISAAC (BORN 1936)

Born in South Africa, Isaac Witkin emigrated to England and attended the St. Martin's School of Art in London. He studied with Anthony Caro, and served as an assistant to Henry Moore. Since his relocation to the United States in the 1960s, he has moved between welded-constructed and cast sculpture. In the 1970s, Witkin expanded his sculptural vocabulary by pouring molten metal into shapes that were later welded together. Sometimes the pour has the fluidity of a drawing, sometimes the character of a geometric model. His foundry studio and home are in New Jersey.

Chaka is shown on page 115.

The Lithuanian-born William Zorach moved to the United States as a young child. He began his artistic calling as a lithographer, working first as an apprentice and then a journeyman in a lithography shop from 1902 to 1908. He spent the following two years as a painting student at the National Academy of Design in New York before finally moving to Paris in 1910, where he met his future wife Marguerite Thompson, herself an accomplished avant-garde painter. His knowledge of African sculpture soon led him to experiment with that medium, and he gave up painting entirely in 1922; he proved to be an important innovator of direct carving.

Different shapes of stone or wood would frequently suggest forms to Zorach, and he would carve as if to release this basic essence of the piece from the surrounding material. He explored universal human themes—lovers, mothers, and children, as well as animals, sculpting all with an expressiveness that was passionate despite his increasing simplification of forms.

In 1929, Zorach began to teach his method of direct carving at the New York Art Students League, teaching for over thirty years and inspiring many students. He wrote *Zorach Explains Sculpture* and his autobiography, *Art Is My Life*, and was also the recipient of numerous awards and honors.

Wisdom of Solomon is shown on page 97.